Watercolor
Handbook

Watercolor
Handbook

THUNDER BAY
P · R · E · S · S

San Diego, California

Thunder Bay Press

An imprint of the Advantage Publishers Group

THUNDER BAY 5880 Oberlin Drive, San Diego, CA 92121-4794
P · R · E · S · S www.thunderbaybooks.com

Library of Congress Cataloging-in-Publication Data

Watercolor handbook.
 p. cm.
 ISBN 1-59223-176-4
 1. Watercolor painting--Technique.

ND2420.W356 2004
751.42′2--dc22

2003063443

QUMCGTW

Manufactured in Singapore by Pica Digital Pte Ltd
Printed in China by CT Printing Ltd.

1 2 3 4 5 08 07 06 05 04

CONTENTS

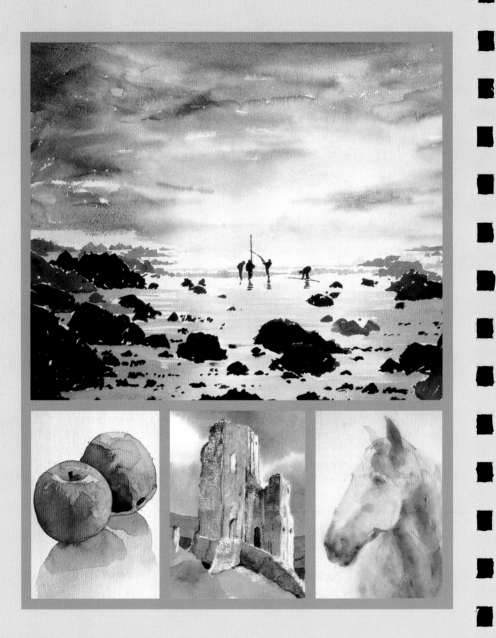

INTRODUCTION

It's easy to see why watercolor painting is so popular. To begin with, there's the sheer pleasure of physically handling such a fluid and responsive medium. There is something calming and therapeutic about watching your brush glide across the surface of the paper like a skater on ice, leaving behind it a drift of color that glistens momentarily, then settles into the fibers of the paper and dries with a luminous inner light.

Watercolor is also a highly expressive and versatile medium. Just as a short poem can say more than a thousand words, a good watercolor is capable of capturing all the glories of nature, of light and sun and air and mist, with just a few brief strokes. It is the unique freshness and immediacy of watercolor that appeals to the artist and viewer alike.

On the other hand, the fluid and transparent qualities that make watercolor so attractive also make it the least controllable and the most unpredictable of the painting media. Things can get pretty hairy sometimes, and you'll need to remain calm when your sky wash suddenly takes off in all directions or develops streaks and runs for no apparent reason.

In addition, painting in watercolor requires a high degree of planning and forethought. With an opaque medium such as oils, you can build up the paint in layers, applying light colors over dark ones and obliterating mistakes by painting over them. But because watercolors are transparent you can't paint a light color over a dark one, as the darker color will show through. This means that you have to know in advance which areas of the picture are going to be light and which are going to be dark, and be prepared to work methodically from "light to dark," cutting around those areas that you want to leave

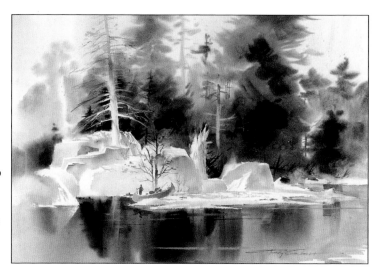

COOL AND
QUIET
by
Tony Couch

as bare paper. If you don't plan things carefully, you may lose control of the painting. Little wonder, then, that people regard watercolor as a kind of "Mata Hari" — her seductive charms are many, but if you make a wrong move you could find yourself in big trouble! It's for this reason that so many people are encouraged to work in watercolor, only to end up frustrated and disappointed when things don't work out quite as they had planned. The problems arise when the enthusiastic but untutored beginner sets out to produce a good painting without first getting to know how the medium behaves and what it is capable of. Also, it's difficult to spot the mistakes in our own work until it is too late (although it's always easy to see mistakes in someone else's

painting!), because we are so involved in the painting process that we cannot step back from it and evaluate it objectively.

The aim of this book is to help you identify any problems — real and potential — and to provide logical solutions, hints, and ideas for the amateur watercolor artist.

The Medium

The term "watercolor" is usually reserved for transparent colors sold in small tubes or pans, but gouache is also water-soluble, as is acrylic paint, which can lead to confusion.

WATERCOLOR AND GOUACHE

Although manufacturers always list the three types of water-based paint separately, art galleries and books sometimes lump them together, so you may see a largely opaque gouache or acrylic painting described as "watercolor" or "watercolor with body color," the latter being a term for opaque paint.

Gouache paint is simply an opaque version of watercolor, made in a similar way, and since the two types of paint are often used in combination in one painting, they are discussed together here.

Transparent watercolor, like all the painting media, consists of pigment, a liquid, and a binding medium, in this case water and gum arabic. Watercolors also contain glycerin and a wetting agent, such as ox gall, to make the paint malleable and prevent it from drying out, and usually also a fungicide. Gouache paints have a larger glycerin content, which makes them more readily soluble than watercolors, and are made opaque by the use of a higher proportion of pigment, or by the addition of extenders such as precipitated chalk.

DIFFERENT CHARACTERISTICS

Because watercolors are transparent, you cannot lay light colors over dark ones. Instead, colors and tones are built up gradually, working from light to dark. In classic watercolor technique, any highlights are "reserved" by leaving them as white paper and painting around them; the paper itself plays an important part, because white reflects back through the thin layers to produce the luminous quality typical of the medium. This can easily be sacrificed if you lay on too many layers of paint, so it is best not to exceed three layers—or four layers at the most—for the darker colors.

Gouache, being opaque, will cover the paper fully, so you can work on colored surfaces and build up from dark to light. But it is still wise to avoid putting on too many layers of paint, especially if you are using it thickly. Because gouache is so easily soluble, each new layer has a tendency to dissolve the one below so that the two mix, causing muddy, dirty-looking colors.

The History

Transparency and the soft harmony of color washes, with highlights and lighter areas rendered by leaving the white paper bare or faintly toned, are the main characteristics of "pure" watercolor painting.

Since the time of the ancient Egyptians, water has been used as a diluent in many types of paint, including size paint, distemper, fresco, tempera, and gouache. True watercolor, however, consists solely of very finely ground pigment with gum arabic (known sometimes as gum senegal) as the binder.

The water-soluble gum acts as a light varnish, giving the colors a greater brightness and sheen. Other substances may occasionally be added to the water in making up the actual paint, including sugar syrup and glycerin. The syrup acts as a plasticizer, making the painting smoother; and the glycerin is said to lend extra brilliance and in warm weather keeps the paint from drying too quickly.

White pigment is never used in a pure watercolor palette. Its addition creates, in effect, a different medium: gouache.

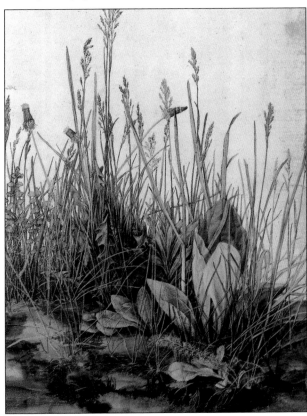

THE PIECE OF TURF
by Albrecht Dürer

Although many medieval illustrators used pure—that is, transparent—watercolor in small works and on manuscripts, others added opaque or body color to make a background on which gold leaf was laid. The first European to fully recognize the value of the medium in larger works, using it extensively in landscape paintings, was the German artist Albrecht Dürer (1471–1528). Although strong lines and opaque passages played their part, the unique transparency of watercolor washes was a major feature of these works.

One of the earliest English artists to make full and effective use of the medium was John White, a draftsman with Sir Walter Raleigh's 1787 expedition to the coast of North America. White's use of the full range of watercolor in clean washes when making drawings for the record of the life and scenery of the North Carolina coast have caused some historians to claim him as the "father" of the English watercolor school.

Only those who have mastered a basic technique and recognized the limitations of a medium can afford to depart from the rules and, in doing so, evolve new styles. Thomas Girtin, for instance, regarded the limitations of watercolor as a challenge and, in effect, increased the challenge by deliberately restricting the range of his palette. He used only five basic colors: yellow ocher, burnt sienna, light red, monestial blue, and ivory black. He applied the paint in thin washes, allowing each wash to dry before applying the next, building up deep tonal gradations and contrasts. Like most of the English school, he left areas of white paper untouched to provide highlights; but occasionally broke a rule by using gouache for the odd highlight.

William Blake devised something akin to offset printing to apply his first layers of color, painting on an impervious surface such as glass, porcelain, or a glazed card or paper, and pressing this over his painting paper. When the print was dry, he worked over it in opaque or body color to elaborate and enliven it.

The distinction between fine art and the art of the illustrator, always blurred, became more so in the nineteenth century with the invention of half-tone reproduction. Overlaying of red, yellow, and blue inks, broken down by screens to produce many tones, made possible the reproduction of illustrations in full color. Watercolor was found to be an ideal medium to submit to the process, which enabled books containing full-color illustrations to be produced comparatively cheaply for the mass market.

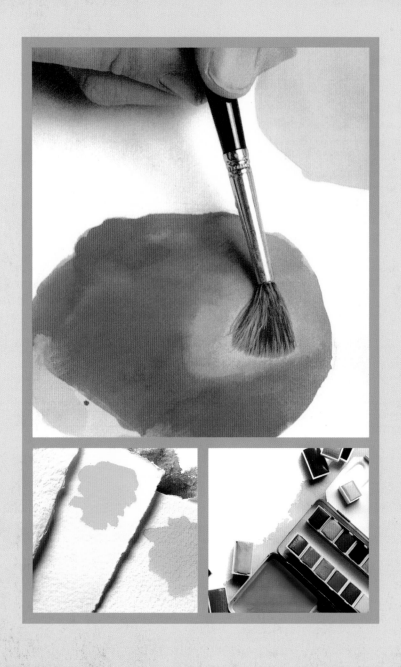

MATERIALS AND EQUIPMENT

Buying new tools and equipment for painting can be exciting, but it is all too easy to waste money on expensive items that you don't really need. It is best to start with the basic essentials, at least to begin with, and then add to them as you gain more experience. You will be able to produce excellent paintings with just a few key items. This section outlines the tools and equipment you will need to get you started. When buying brushes, paints, and papers for watercolor painting, it is best to buy the best you can afford. You will get far better results right from the start and this will increase your confidence, even if you are a complete novice.

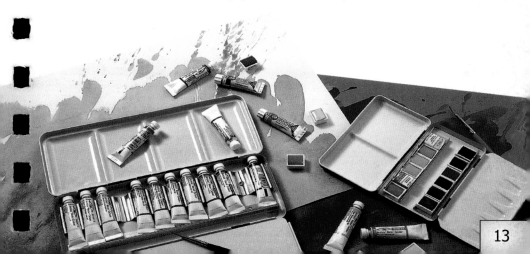

Paints and Colors

In buying watercolors, price more accurately reflects the quality of any other medium.

Large, cheap, multihued boxes of so-called watercolor, muddy, impermanent, and consisting more of filler than pigment, may delight the eye of a child but are useless for serious work. "Students' Colors," usually put in smaller boxes or in tube-color sets, are good for practice, especially if made by a reputable company. But only those paints labeled "Artists' Colors" can be relied upon to give the transparency, glow, and permanency that the keen artist,

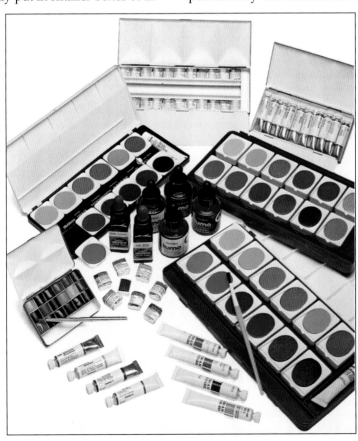

professional, or amateur requires. In this expensive, highest-quality range, there is no essential difference—except in terms of portability and convenience—between "solid" and tube colors. The quality brands to keep in mind are Winsor and Newton, Rowney, Reeves, and Grumbacher.

Dry cakes and semimoist pans are little-used today; half-pans, also semimoist, are more common. The best-quality half-pans can be bought singly in their tiny white boxes, and are often sold as sets in small, flattish tins that double as palettes.

Semiliquid tubes of watercolor are preferred by artists who wish to apply large washes. Fully liquid watercolor can be bought in bottles, with an eyedropper provided to transfer paint to palette. Good brands include Luma and Dr. Martin's. It is obviously quicker to use these, or the watered-down "liquid" tube color, than to lift color from a half-pan with a wet brush to make up a wash.

Watercolors are available in sets as well as in individual pans or tubes. Half-pans (back, center, and center left) can be purchased both individually and in sets. The boxes (left and right) can easily double as palettes. Bottled, concentrated watercolors (center) usually have an eyedropper applicator. Tube colors (front and back) just need to be squeezed onto the palette before being used.

Few watercolor artists, even the most expert, would claim to use more than a dozen colors, from which the whole range could be mixed. But early English watercolorists like Thomas Girtin painted masterpieces using a palette of no more than five basic permanent colors. There is certainly no need for any artist to keep any more than ten or eleven colors.

An adequate modern palette includes: ivory black, Payne's gray (optional), burnt umber, cadmium red, yellow ocher, cadmium yellow, Hooker's green, viridian, monestial blue, French ultramarine, and alizarin crimson.

Professional artists may argue about the "best" basic palette, but few would disagree that a beginner or early student is best advised to stick to a restricted palette, which not only forces him to consider the basics of color mixing but imposes a pleasing harmony and consistency on the finished work.

Some pigments with a chemical dye base will stain paper rather than create a transparent wash on the surface. The "stainers," which might be quite useful for certain purposes, can be easily spotted: blob the color on paper and let it dry, then rinse under running water. Stain pigments will remain.

GENERALLY AVAILABLE COLORS

Cadmium Red Alizarin Crimson Light Red Rose Madder Alizarin Venetian Red

Lemon Yellow Cadmium Yellow Permanent Yellow Yellow Ocher

 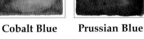

Viridian Hooker's Green Terre Verte

Cobalt Blue Prussian Blue Cerulean Ultramarine

Cobalt Violet

Burnt Umber Raw Umber Raw Sienna Burnt Sienna

Ivory Black Payne's Gray Chinese White

16

SUGGESTED BEGINNERS' PALETTE

Cadmium Red **Alizarin Crimson** **Cadmium Yellow** **Yellow Ocher**

Cobalt Blue **Prussian Blue** **Viridian** **Burnt Umber**

Payne's Gray **Ivory Black**

Purists—and experimenters—can make their own watercolors at home or in the studio. It is a time-consuming process, but some may find it worthwhile. One would need finely ground pigments of the finest quality, a plate glass slab, a grinding miller or muller, a plastic palette knife or spatula, gum arabic, glycerin, distilled water, ox gall, sugar solution, and carbolic acid solution.

Pour one part of mixed sugar and glycerin solution plus two or three parts of gum arabic and a few drops of ox gall into a little pool on the glass. Then, with the palette knife, slowly draw in and mix the little heap of pigment placed beside it until there is a stiff paste. Grind this with the muller and scrape the mixture into a pan.

Paper

Good-quality watercolor paper is essential. Ordinary cartridge paper is fine for drawing but unsuitable for watercolor painting, as it is too smooth and too thin.

Watercolor paper is available in single sheets and in pads and blocks. It can be either handmade or machine-made and this difference is reflected in the price. The best-quality handmade paper is made from cotton rag instead of wood pulp. Handmade papers are generally recognizable by their irregular surface and ragged (deckle) edges. They also bear the manufacturer's watermark in one corner.

Mold-made papers are the next best thing to handmade, and are more affordable. Machine-made papers are the cheapest, but some have a rather mechanical surface grain.

TEXTURE

It is important to choose the right kind of paper, as its surface texture influences the way the watercolor washes behave. The surface texture of paper is known as its "tooth." There are three kinds of surfaces.

Hot-pressed (HP) is smooth, with no tooth. It is suitable for finely detailed work, but not for heavy washes, as the surface tends to buckle and the pigment settles unevenly.

Cold-pressed (otherwise known as "Not," since it isn't pressed) has a semirough surface equally good for vigorous washes and fine brush detail. This is the most popular type and is ideal for less experienced painters.

Rough paper has a pronounced tooth that breaks up the edges of a wash and produces interesting textures.

WEIGHT

Traditionally the weight (or thickness) of paper is measured in pounds per ream (480 sheets). As a guide, the lightest watercolor paper is 72 lb. while a middleweight paper is 140 lb. The heaviest paper weighs 300 lb. The middleweight paper is fine for general use, provided it is properly stretched to prevent buckling (see next page).

Tinted paper Drawing paper Handmade paper

STRETCHING PAPER

1 Paper expands when it absorbs water and shrinks again when it dries. If the stretched wet paper is held firm while drying, it will not expand and cockle when rewetted during painting. Begin by thoroughly soaking the paper in water in a bath for 15–20 minutes, without letting it float — the thicker the paper, the longer it should be soaked.

2 Lay the paper on a rigid board 1 in. bigger all around than the sheet. The board should be waterproofed — either varnished or melamine-coated — to prevent mold, and must be placed horizontally. Make sure that the paper is smooth, with no bumps. Remove large air bubbles by lifting the corners of the sheet.

3 Cut four lengths of broad, brown paper gumstrip, 2–3 in. wide, to the same size as the board (don't use masking tape, as it won't stick when damp). Wet the tape.

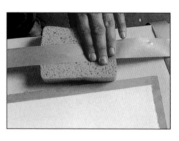

4 Lay the tape along the edges of the paper so that the strips overlap at the corners. One-third of the width of the tape should adhere to the paper and two-thirds to the board. You can speed up the drying process by using a hair dryer. When dry, paint with the paper still taped to the board, then cut it off with a knife.

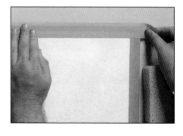

Rough paper

Cold-pressed or Not paper

Hot-pressed paper

Brushes

Your brushes are probably the most important items in your painting kit, so buy the best you can afford. A few really good-quality brushes will last longer and give you far better results than a whole fistful of cheap ones.

Pure sable brushes are the best, but they are expensive. An excellent, cheaper alternative is sable blends — sable mixed with synthetic hairs. Like sables, they hold their shape well, are springy and resilient, and are a pleasure to use. The cheapest brushes are made of synthetic fibers. While they are a good value, their drawback is that they do not hold as much water as natural-hair brushes and so tend to dry up in midwash on occasions, which can be annoying.

BRUSH SHAPES AND SIZES

Brushes come in various shapes, each creating its own brushstroke. It would be impractical, however, to switch brushes for each

CHOOSING A BRUSH

• The heads of new brushes are brought to a fine point and coated with starch size to protect them in transit. Always try out a brush before you buy it. Dip the brush in water to wash out the starch size (a good art supply store will always have a pot of water available for this purpose). Flick the brush once to test that the hairs come to a good point. If they do not, reject the brush and try another.

• Having purchased a good brush, it makes sense to look after it. Rinse it out thoroughly after use, flick out the excess water, and then reshape it, either by gently drawing it over the palm of your hand or molding the hairs to a point. Then stand it, hairs uppermost, in a jar or lay it flat. If the hairs are allowed to dry out bent, the brush will be ruined.

brushstroke, and part of learning watercolor technique is discovering how many different marks can be made with one brush. The round brush is the most versatile because it holds plenty of paint for laying large washes and also comes to a fine point, enabling you to paint fine details. Mop brushes and wash brushes are designed to paint large areas quickly. Wash brushes are wide and flat, while mops have large, round heads.

The square-ended flat brush is used for making broad, straight-edged strokes.

The rigger brush has extralong flexible hairs and is used for painting very delicate lines. These latter two are specialty brushes, worth experimenting with, but only when you feel ready to add to your basic equipment.

Brushes are graded according to size, ranging from as small as 0000 to as large as a no. 24 wash brush. The size is printed on the brush handle. Brush sizes are not standardized, so a no. 5 brush in one manufacturer's range will not necessarily be the same size as a no. 5 in another's.

You will need at least two round brushes initially — say, a no. 2, 3, or 4 and a no. 12, 14, or 16. If you like working on a large scale, you may also need a mop or wash brush for applying broad washes of color.

You only need a few brushes for watercolor painting (from left to right): rigger, flat, mop, large round, small round.

• MATERIALS AND EQUIPMENT •

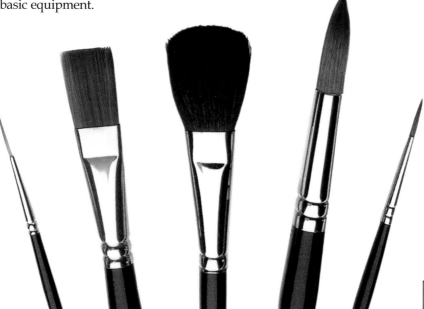

21

Boards, Easels, and Palettes

You will need a lightweight wooden board to attach the paper to. Laminated boards are not suitable because the sticky paper tape used in stretching paper does not adhere to it.

Before buying an easel, the watercolorist should give careful consideration to his requirements. A large variety of easels is now available, so the artist should be able to find a suitable one without difficulty. The best studio easels can be adjusted to a horizontal position for sketching. Many watercolorists work outside. For this type of painting, some artists prefer to work with only a drawing board and pad, but there are many collapsible, lightweight easels that are also suitable. Some portable easels are provided with a compartment for carrying materials. Generally, aluminum easels are cheaper than wooden ones. However, as these easels are very light, it is advisable to buy one that has spikes on the

feet to hold the easel firm in windy conditions or on soft ground. The sketching easel (**1**) has rubber-tipped feet but it can be supplied with spikes if necessary. It is made from beechwood, a very hard-wearing wood. The adjustable legs enable the artist to work at a comfortable height. When fully extended, this easel will hold a canvas at a fixed height, either in a vertical position or tilted forward to any desired angle. It is easy to carry, weighing only about 4 lb. The aluminum sketching easel (**2**) is slightly larger. It is fully adjustable.

A disadvantage of this easel is that it only has rubber feet, which will not always keep the easel steady. The aluminum table easel (**3**) is extremely light.

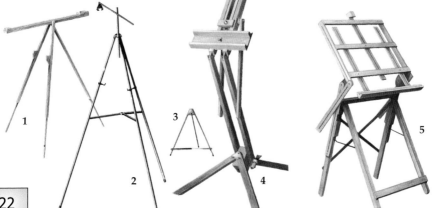

1

3

2

4

5

When not in use it folds up compactly and can be stored out of the way. The radial studio easel (**4**) is made of wood and it can also be folded to take up less space. The easel may be tilted backward and forward as well as the canvas, which can be moved to a horizontal position. There is a large wing nut to lock the easel steady. The combination easel (**5**), made of seasoned beechwood, is both a folding studio easel and a drawing table. This makes it extremely practical for artists who have small studios. It will take a very wide canvas, tilted at any angle or kept in an upright position. When it is used as a drawing table, the frame for the drawing board can be adjusted easily to a comfortable height. The frame will hold drawing boards of any standard size or type. Another easel for outdoor work is the combined sketching seat and easel (**6**). This versatile easel can be used with canvas, block, frame, and sketching board. It is fully adjustable and is easily carried by the handle attached to the seat.

A useful piece of equipment for artists who work outdoors is the combined satchel and stool (**7**). A strap is attached to the light metal legs of the stool, so it is easy to carry. All the artist's materials, such as paints, brushes, and paper, can be put in the satchel.

PALETTES

Watercolors are available in sets as well as in individual pans or tubes (see page 14). Half-pans can be purchased both individually and in sets. The boxes can easily double as palettes. Bottled, concentrated watercolors usually have an eyedropper applicator. Tube colors just need to be squeezed onto the palette before being used.

Recessed or well palettes must be used for mixing watercolor so that any quantity of water required can be added and colors cannot flow together. Palettes of ceramic, plastic, or metal are suitable, and come in a variety of different sizes and shapes. It is really a matter of personal choice whether a separate small pot is used for each color or whether the paints are kept together in a large palette with several wells. The traditional kidney-shaped palette with a thumbhole, which can be held in the hand, may be more useful for outdoor work where flat surfaces are not available, but for studio work, no one style is more valuable than another.

6

7

• MATERIALS AND EQUIPMENT •

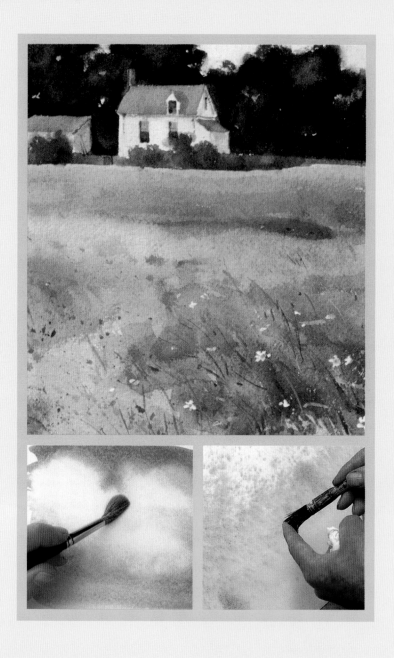

TECHNIQUES

There are perhaps half a dozen techniques that form the foundation of all watercolor painting, and an understanding of them will give you the confidence to go on and exploit the many possibilities of this versatile medium. You can have a lot of fun making brushstrokes and laying smooth washes to get the feel of the paint and what it will do on the paper.

This section focuses on the methods used in watercolor works in both past times and the present day. Those new to the medium will find the step-by-step demonstrations easy to follow and instructive, while more experienced painters may discover new tricks of the trade.

Washes

The first basic requirement of watercolor painting is learning how to lay washes smoothly and with ease.

Washes are best applied quickly and in one go, so mix more paint than is needed and apply it with a large, well-loaded brush. Keep the wrist supple and work quickly and confidently so that the brushstrokes flow into each other. Once a wash is applied, leave it to dry undisturbed.

Flat washes were used for this color sketch. When dry, color was washed off in places to suggest light reflecting off the rooftops and windows.

LAYING A FLAT WASH

The purpose of a flat wash is to cover large areas that cannot be done with one brushstroke. To achieve a smooth, even tone with no unwanted marks or lines, work on stretched paper. Dampen it with clean water using a sponge or a large wash brush. The dampness of the paper will help spread the color evenly.

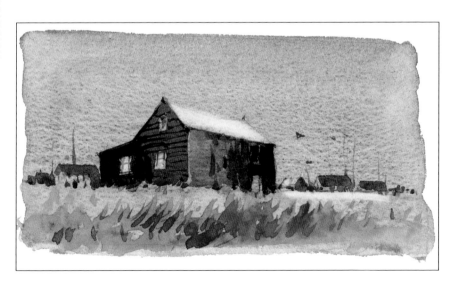

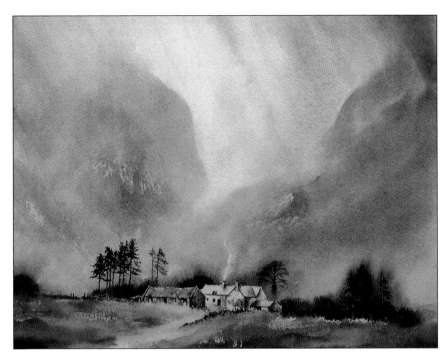

In the picture above, the atmospheric effect of mist and sunlight is achieved with weak washes of cobalt blue, burnt sienna, and cadmium yellow, applied wet-on-wet. The board was tilted back and forth to encourage the paint to run downward.

When learning how to handle watercolor, remember the three Ps: patience, perseverance, and practice. Patience is needed because, depending on the humidity and the type of paper being worked on, watercolor washes may dry more slowly or unevenly than anticipated. To avoid backruns and muddy colors, the artist must be prepared to allow one wash to dry before adding another on top (unless working wet-on-wet, of course). Generally, the best time to apply a second wash is when the shine has just left the first wash. This can be judged by holding the board up to the light horizontally and at eye level.

Perseverance is a good virtue because things inevitably will go wrong. But, after all, the capricious nature of watercolor is part of its attraction! If a mistake is made, it's not the end of the world. Learn from it and move on to the next challenge.

Pure watercolor, being transparent, must be applied from light to dark. The paper itself is used to create the pure white or light tones that with opaque paints would be made by using white alone or mixed with colored pigment.

Any area required to be white is simply "reserved," or left unpainted, so that when it is surrounded with darker washes, it will shine out with great brilliance. Pale tones are created in the same way, with a light-colored wash put on first and then surrounded with darker tones. Light reflected off the paper and back through these thin skins of paint (known as washes) gives watercolor paintings a spontaneity and sparkle that cannot be achieved with any other medium. Hence watercolor's popularity with artists both past and present.

The wash is the basis of all watercolor painting, whether it is a broad, sweeping one covering a large expanse such as a sky, the background to a portrait, or a much smaller one laid on a particular area. Washes need not be totally flat. They can be gradated in both tone and color or broken up and varied. But the technique of laying a flat wash must be mastered, even if it is seldom used by the artist.

The support should be tilted at a slight angle so that the brushstrokes flow into one another but do not run down the paper. For a broad wash, a large chisel-end brush is normally used; for a smaller one or a wash that is to be laid against a complicated edge, a smaller round brush may be more manageable. Laying a wash must be done quickly or hard edges will form between brushstrokes.

A flat wash in a vivid color is being laid on dampened paper with a broad, flat-ended brush. It is not necessary to dampen the paper (many artists prefer the slightly dragged look given by working on dry paper), but

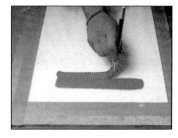

dampening facilitates an even covering. Tilt the board slightly so that the brushstrokes flow into one another, and work backward and forward down the paper until the whole area is covered.

LAYING A FLAT WASH WITH A SPONGE

Another method of laying a wash is to use a sponge. This is particularly useful when a slightly variegated or textured wash is desired, as the sponge can either be filled with paint for a dense covering or used relatively dry for a paler effect. A sponge can also be used in conjunction with a brush. If, for instance, it is rinsed in clean water and squeezed out, some of the paint laid by a brush can be removed while it is still wet, thus lightening selected areas—a good technique for skies or distant hills.

1 The wash is mixed with a brush and tested on a piece of spare paper.

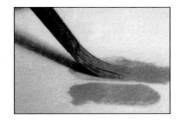

2 Enough paint is mixed to cover the area and the sponge is dipped into it. For a lighter covering, some of the paint can be squeezed out.

3 A variegated effect is achieved by applying the paint quite thickly with the first stroke, much more thinly with the second.

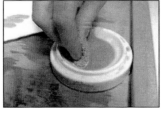

4 The final wash can be worked in with the sponge while it is still wet in order to lighten some areas and produce a soft, shimmering effect.

Graduated and Variegated Washes

Colors in nature are seldom totally flat or one solid hue. It is often desirable, therefore, to lay a graduated wash, which becomes darker or lighter at the top or bottom or changes from one color to another.

WATERCOLOR HANDBOOK

For a graduated wash, simply mix more water with the paint to make each successive strip lighter or more pigment to darken them. For a variegated wash, mix up the two or more colors to be used, dampen the paper as usual, and then lay on the colors so that they blend into one another. The effect of such a wash cannot be figured out precisely in advance, even with practice—the artist should be prepared for a happy (or unhappy) accident. As with a flat wash, never make corrections while the paint is still wet; if you are dissatisfied, it can be sponged out when it is dry and a further wash laid on top.

Some watercolorists use variegated washes in a particularly free way. Each individual arrives at his own technique by trial and error. Attractive efforts can sometimes be achieved by deliberately allowing the paint to flood in the middle of a wash by introducing blobs of strong color to a paler wash while the paint is damp or by laying one wash over a dry one, thus producing a slight granulation of the paper. Such effects are unpredictable. For one thing, they vary widely according to the type of paper used. But one of the great joys of watercolor is the opportunity it provides for turning accidental effects to advantage.

LAYING A GRADUATED WASH

A graduated wash starts with strong color at the top, gradually lightening toward the bottom as more water is added to the paint.

TIP
FOR A PROFESSIONAL RESULT

• Tilt the board at a slight angle to allow the wash to flow down gradually; if laid flat the paint could creep backward, staining the wash.

Such washes are often used in creating the illusion of space and recession when painting skies, which appear strongest in color directly overhead and gradually pale toward the horizon.

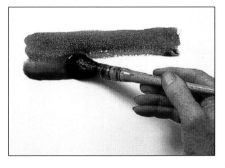

1 Start as for a flat wash, laying a band of full-strength color across the top of the paper. Quickly dip the brush into clean water and run it under the first stroke, picking up the paint that has run down to the base of the first stroke.

2 Continue down the paper, adding bands of increasingly diluted paint. The bottom band will be very pale indeed, almost clear water. Leave the paper to dry.

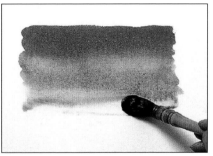

LAYING A VARIEGATED WASH

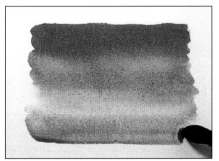

As for flat and graduated washes, you can apply bands of different color or value to create a variegated wash. This technique is often used in painting skies and landscapes.

At first you may find that your graduated wash appears a little striped, but with practice you will grasp the delicate balance of pigment and water required to create a smooth, even gradation of color.

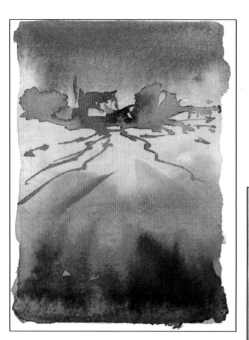

Left: Graduated and variegated washes were allowed to dry and then the landscape details were overlaid with sharper, crisper strokes.

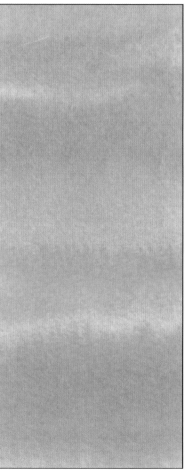

Right: Prussian blue and alizarin crimson have been allowed to run into one another, just as they would with a wash of only one color. Such effects are impossible to control accurately; the artist must be prepared for a happy accident.

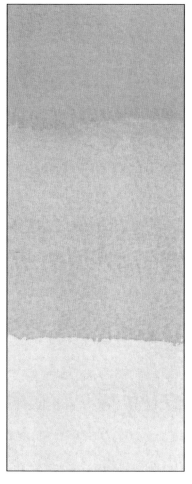

Above: Laying one wash on top of another often gives textural variety as well as intensifying the color. Notice that the bottom band, a pale wash of Payne's gray, is quite even, while the one at the top, a third application of the same wash, shows distinct brushmarks.

Above: The possibilities of working wet-on-wet may be explored by producing this kind of doodle in a matter of minutes. The wet-on-wet technique is often used in the early stages of painting, or for the background, more precise work being done at a later stage or in another area of the painting.

The sky has a slight, but very important graduated wash, which is a mirror image of the expanse of water and which it counterbalances. The dark clouds above have been added wet-on-wet to the wash.

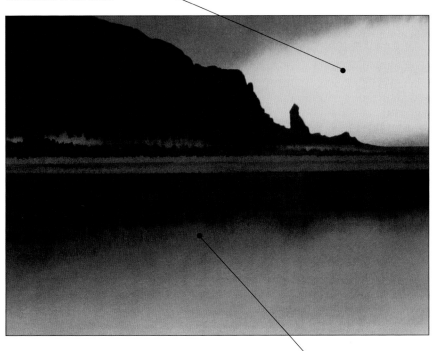

HEADLAND by Robert Tilling

The sheer simplicity of this painting belies its deftness and skill. The near-perfect gradation of tone across the glassy water could only have been achieved by a skillful application of the right amount of pigment to paper of optimum wetness, with a minimum of strokes. The impact of the work is stunning, as the eye is drawn to the eerie silhouette of the rocky pillar set against a luminously pale wash.

Much control was needed to create the hazy, dark reflection of the mountains without losing the calmness of the water surface. The edges of the reflection are almost imperceptible.

The white disk of the sun was masked to retain the white paper. The halo was produced through careful blending of the surrounding wet wash using a small brush.

The gradual transition from yellow to blue was achieved by painting the two bands of color side by side into a damp surface and merging them with horizontal strokes of a damp brush.

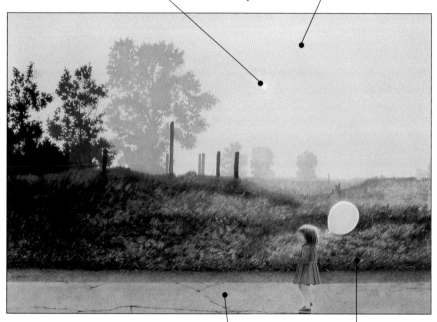

MORNING WALK by Walter Garver

This graduated wash plays a crucial role in dictating the mood of this picture. The subtle transition of color across the sky, particularly around the sun, is the vital factor in the portrayal of the misty morning light. The top half of the picture is taken up with the sky and all the detail is confined to the bottom half. The silhouettes of the trees break up the sky area. The largest of these is closest to sky in color and tone.

The detailed grass was painted over an underpainting of bright yellow. The sense of yellow light permeating the whole scene is reinforced by the way in which the underpainting has been allowed to show through.

A pale yellow wash was first applied as an underpainting, upon which the gray paint was brushed and spattered, followed by the fine detail of the cracks in the surface. This gives the road a slight yellow bias, echoing the color of the sky.

Working Wet-on-Dry

Watercolor paint can be applied to either a wet or dry surface. The effects produced are very different, and often the most interesting pictures are those that combine both methods.

Working on a dry surface, the marks made have a sharp, well-defined edge and do not spread. They are therefore totally under your control. Painting wet-on-dry is sometimes called the "direct" technique. It produces paintings that seem to sparkle with light because inevitably tiny patches of white paper will be left untouched by paint.

Rich color effects can be obtained

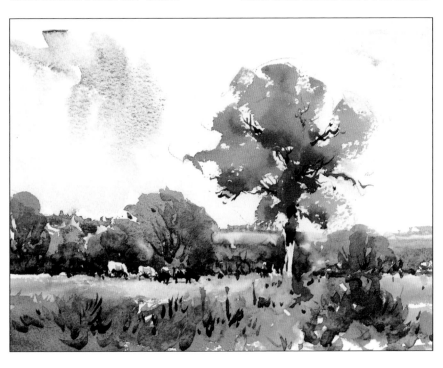

This sketch was done on dry paper using the direct method. Transparent layers of color are applied one over the other.

by applying a wash, allowing it to dry, and then applying a second wash over it so that the underlying color shows through. For example, try painting a wash of blue over a dry wash of yellow to create green. You will find the resultant color more transparent and luminous than if you mix the blue and yellow together on the palette. This is because light is reflected back off the white paper through the thin layers of color.

1 A wash of bright yellow is brushed onto paper and allowed to dry.

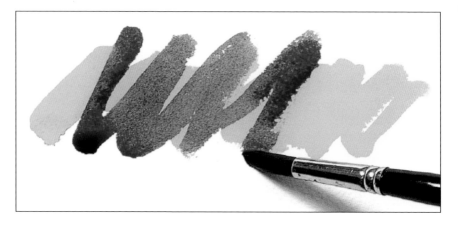

2 A transparent wash of blue is quickly brushed over the yellow to produce a green.

Painting Wet-on-Wet

Without a doubt, the most beautiful and atmospheric effects in watercolor painting are produced by working wet-on-wet.

Now we come to the most beautiful, the most expressive, and the least controllable method. Again the paper is wet, but this time more water is carried in the brush. The deposited pigment, being more diluted, floods out and into the wet paper and creates exciting diffusions and color interactions that could never be equaled if they were planned. Of course, the potential for disaster is there too, streaks and "backruns" being the main problem. But then, watercolorists like to live dangerously.

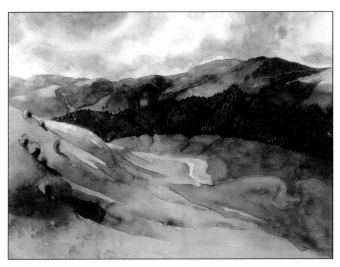

SHADES OF SUMMER
by Moira Clinch

Here, blues and yellows are blended wet-on-wet to create lively variations of color.

In this technique wet color is applied to wet paper, or wet color is charged into wet color. It allows the mixing of colors on the paper's surface rather than on the palette. The colors spread and merge gently together, and dry with a soft, hazy quality. Wet-on-wet is particularly effective for painting skies and water, producing gentle gradations of tone that evoke the ever-changing quality of atmosphere and light.

Working wet-on-wet requires confidence and careful timing because you can only control the paint to a certain extent. Charge your brush fully and work quickly and confidently, allowing the colors to spread and diffuse on their own accord. A common mistake when working wet-on-wet is to dilute the color too much, with the result that the finished painting appears weak and insipid. Because the paper is already wet, you can use quite rich paint—it will soften on the paper but retain its richness. You must also compensate for the fact that the color will dry lighter than it appears when wet.

It is best to use a heavy-grade paper, stretched and firmly taped to a board to keep it from warping and wrinkling when wet washes are applied.

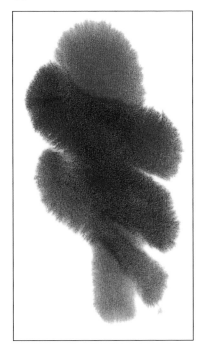

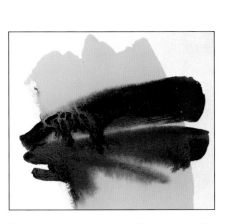

Here are two examples that illustrate the effect of a fully loaded brush applied to wet paper. Working wet-on-wet produces soft, diffused shapes that can be used to suggest clouds, mist, and rain.

Backruns

There is no remedy for a backrun except to wash off the entire area and start again. However, many watercolor painters use them quite deliberately, both in large areas, such as skies or water, and in small ones, such as the petals of flowers, for the effects they create are quite unlike those achieved by conventional brushwork.

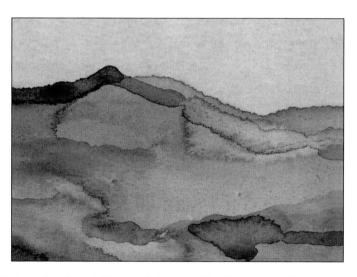

Above: Backruns have been deliberately induced and then blown with a hair dryer so that they form definite patterns. Techniques such as this are particularly useful for amorphous shapes such as clouds, reflections, and distant hills.

For example, a realistic approximation of reflections in gently moving water can be achieved by lightly working wet color or clear water into a still-damp wash. The paint or water will flow outward, giving an area of soft color with the irregular, jagged outlines so typical of reflections. It takes a little practice to be able to judge exactly how wet or dry the first wash should be, but as a guide, if there is still a sheen on it, it is too wet and the colors will merge together without a backrun as they do in the wet-on-wet technique. These are both a nuisance and a delight to watercolor painters. If you lay a wash and apply more color into it before it is completely dry, the chances are that the new paint will seep into the old, creating

strangely shaped blotches with hard, jagged edges—sometimes alternatively described as "cauliflowers." It does not always happen: The more absorbent or rough-textured papers are less conducive to backruns than smoother ones, and with practice it is possible to avoid them altogether.

In the painting below, the artist has lost control of the sky wash and a huge, hard-edged backrun has appeared in the middle of it. A backrun is a pale, circular mark with a hard, dark edge that vaguely resembles a flower—hence, it is also known as a "flower" or "bloom."

TIPS
TO AVOID BACKRUNS

• Always wipe any excess water off your brush before picking up the paint.

• Try to avoid working back into a wash that has not yet dried.

• If you must modify an area, wait until the previous wash is dry or almost dry. (You can judge this by holding the paper horizontally up to the light; if the surface looks shiny, it is still too early to apply a second wash.)

• TECHNIQUES •

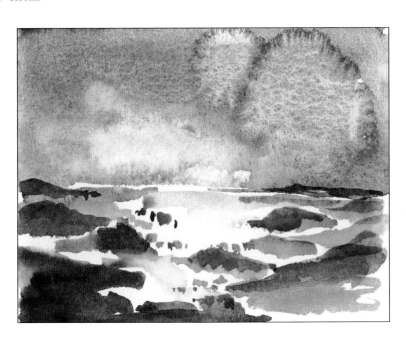

41

CORRECTING A BACKRUN

If you do get a backrun, the painting can be saved if you act quickly enough. You can lift off the excess pigment with a piece of soft, natural sponge to form a lighter, soft-edged shape. Or, you can simply paint a darker shape over it using slightly thicker paint on an almost-dry brush. Sometimes a linear backrun will form along an edge of the paper. This occurs when a watercolor wash is overlapped onto the waterproof surface of the supporting board and starts to run

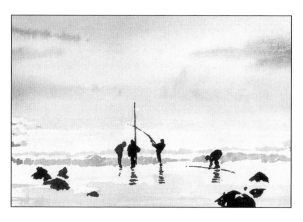

If a backrun occurs in a sky wash, you can blot it out while it is still forming. Use a natural sponge (not a tissue) to lighten the area and soften the edges.

This detail from the upper right of the sky area shows how small backruns can actually be incorporated into the painting. Here they form the upper edges of cumulus clouds.

back into the still-damp wash on the paper. This can be corrected by stroking over the edge with a sponge or a clean, damp brush and drying the board as well.

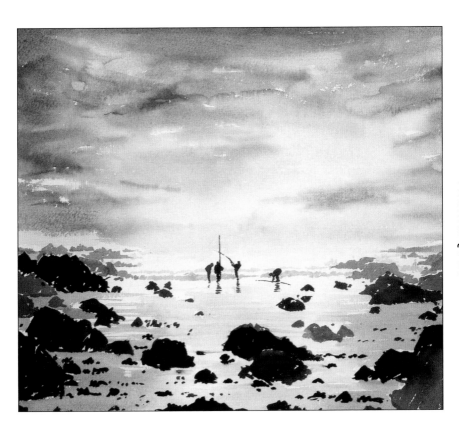

FISHING AT LOW TIDE, GUERNSEY
by Lucy Willis

Building Up

Watercolor is a semitransparent medium, which means that light colors cannot be laid over dark. This is why the traditional method of painting in this medium involves laying down the lightest tones first, then building up the picture with applications of progressively darker colors.

The method does require some forethought. For example, you will need to consider where you wish to reserve any white highlights and indicate these on a light, preliminary drawing. Because of the translucency of the medium, you will also need to think about the effect of earlier washes on subsequent colors—blue underlying red will make the red cooler, for example. Think, too, about the final balance of tone—the relationship between lights and darks—that you wish to achieve.

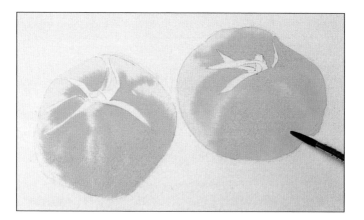

1 Apply a wash of clean water to the areas you want to color. This will help you achieve a softer effect. Remember not to wet those parts that you want to reserve or the color will flow into them (in this case, the stalks of the tomatoes). Now apply the lightest color—cadmium yellow deep— and, while still wet, work in the next tone—cadmium orange deep—for the slightly more shadowed areas.

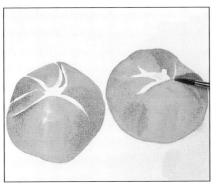

2 Keep building up the forms gradually with successively darker tones. Here, the artist starts modeling the tomatoes with applications of cadmium red light, making the color deeper and denser in the more shadowed areas.

3 Continue the gradual process of building up. Cadmium red light mixed with permanent red deep gives a rich tone and three-dimensional quality to the tomato shapes.

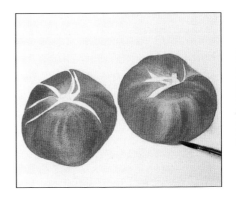

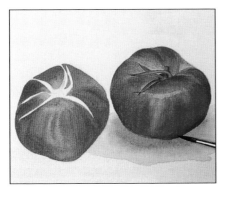

4 Add the final details. Although the tomatoes have a convincing, rounded form, they still appear to be floating in space. A shadow under each one, made from a thin wash of permanent red deep and Hooker's green, anchors them to the surface. Apply a mixture of Hooker's green and olive green for the stalks.

Body Color

Watercolor is renowned for its translucency. The term "body color" simply refers to water-based paint that is not translucent, but opaque.

In the past, it was used to describe Chinese white applied either on its own or mixed with transparent watercolor. Today the term usually denotes pure gouache. Zinc white gouache is an alternative to Chinese white and may be mixed with watercolor to produce a similar milky effect. Where areas of white paper have not been reserved for highlights, body color may be applied instead. It is also useful for strengthening highlights and for overlaying areas that are untidy or have been overworked. A painting of anemones demonstrates the technique here.

1 Begin by applying a pale watercolor wash all over the paper, working wet-on-dry and dampening the brush to spread the color. While this wash is still just damp, drop in patches of watercolor in rich hues for the flowers. Allow the color to spread into petal shapes, adding more as necessary and softening the edges with diluted colors if needed.

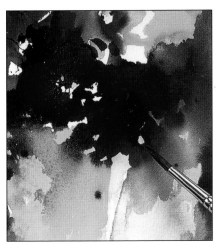

2 Add darker tones of the same colors to suggest the centers of the flowers and to increase the intensity of color (remember that watercolor dries lighter). This should be done when the underpainting is still damp but not wet, but don't worry if backruns occur. Detail may be added with a fine brush or a willow stick.

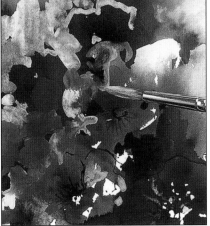

3 Now apply the body color. Mix zinc white gouache with the colors used previously and apply loosely to the edges of the petals, ensuring that the gouache mix is opaque enough to cover even the darkest tones.

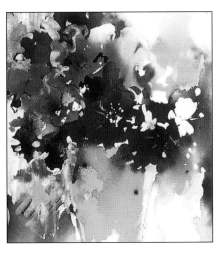

4 The finished painting shows how the application of body color creates highlights, defines the edges of the petals, and clarifies the image by masking out any overworked or confused areas.

Hard and Soft Edges

Achieving hard or soft edges in a watercolor painting depends on one simple principle: A damp base allows watercolor to spread; a dry base contains it.

If you work wet-on-wet, either on dampened paper or a damp wash, the wetness of the underlying surface acts as a conductor, allowing the paint to bleed outward and to dry with a soft, blurry edge.

Conversely, working wet-on-dry—applying a wash to dry paper or dry underpainting—keeps the paint contained within the area to which it has been applied so that it dries with a hard edge. To demonstrate this, dampen a patch of paper with clean water, allow it to dry slightly, then drop in a watercolor wash. As will be seen, the paint spreads only as far as the edge of the damp patch and no further. (Hard edges can also be achieved with masking.)

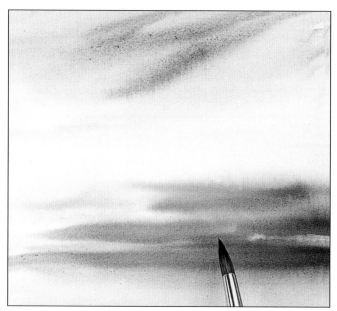

1 Working wet-on-dry, apply a thin, greenish-blue wash of watercolor. While still damp, add streaks of the same color, less diluted, for the clouds and the lake in the foreground. These will bleed into the damp underpainting to produce soft-edged forms. Leave to dry thoroughly.

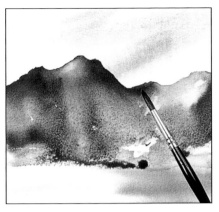

2 Using a darker wash, paint in a jagged band of color for the crests of the mountains, drawing the color downward with a damp brush but leaving the wash to dry to a hard edge at the top. To avoid too solid an area of color, lift off the wash in parts by dabbing with tissue paper, paper towel, or a clean, dry brush.

3 Continuing to work wet-on-wet, paint an even darker color along the base of the mountains to define the banks of the lake. Note how where the wet wash meets the dry underpainting, a hard edge is formed. Where you wish to achieve soft edges on areas that are already dry, as in the foreground, dampen the dry underpainting with clean water before applying this wash.

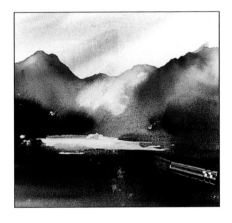

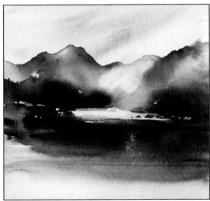

4 The finished painting demonstrates the hard and soft effects that can be achieved by controlling the dampness of the surface. Note how the colors used have dried lighter than they were when wet, a factor that must always be kept in mind when painting in watercolor.

49

Toned Ground

Pretinting the surface on which you are going to paint has various advantages.

First, although colored papers are available for watercolor painting, tinting your own paper allows you to achieve the exact tone and color you want. Second, because a toned ground shows through the colors laid over it to some extent—especially if you leave small patches of paper unpainted—it has a unifying effect on the picture.

This is further enhanced if you restrict your palette to no more than three or four colors. And third, it allows you to build up deeper tones with fewer washes and less risk of muddying. When preparing a toned ground, consider whether you want the finished picture to appear "warm" or "cool," and choose your tint accordingly.

1 Working wet-on-dry, lay a pale wash of a warm color—in this case, quinacridone gold—over the entire surface. Don't worry if the wash is streaky at this stage. These streaks will fade as the paint dries and the wash will become paler and more even. Leave to dry completely.

2 Paint a band of brown madder along the horizon, then lay washes of French ultramarine for the rocks on the horizon and the sea in the foreground, allowing patches of the toned ground to show through. Note how the warm tone of the ground alters the color of the overlaid washes, particularly the ultramarine.

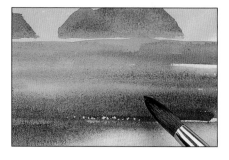

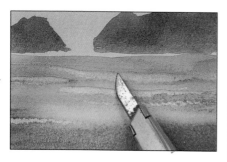

3 While these washes are still damp, scrape away some of the color to create highlights in the sea.

4 Paint darker bands of ultramarine for the waves in the foreground. Then, when all the washes are dry, add body color — pure white gouache — for the sparkling along the horizon.

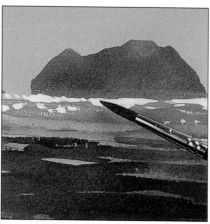

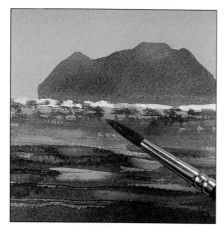

5 Finally, work in a few patches of brown madder and ultramarine next to the white gouache to strengthen the contrast.

6 Note how the toned ground unifies the whole of the finished painting and gives the scene a warm glow, suggestive of sunset. Note, too, how the tones of the sea and rocks become paler as they recede into the distance, creating a sense of depth.

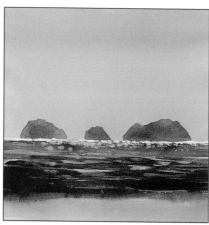

Glazing

The glazing technique depends on the translucence of watercolor and is one of the joys of the medium, enabling you to build up layers of transparent color like a collage of overlaid tissue paper.

When glazing, remember that the underlying color will alter the one you place on top and vice versa, an effect that you can manipulate to darken or lighten a color, make it warmer or cooler, or make an object recede or come forward in space.

This same principle is the one that gives watercolor its luminosity, for it is the whiteness of the paper shining through the layers of color that makes them seem so brilliant. Here are two examples of the glazing technique.

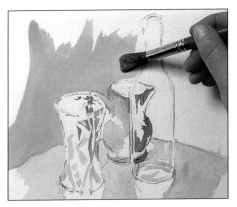

1 Apply thin washes to the subject—yellow ocher for the background, cerulean blue for the table, French ultramarine for the pitcher. Suggest a few reflections in the glass of the vase with emerald green and ultramarine. Leave to dry thoroughly.

2 Continue to build up the paint with thin washes that allow the underlying colors to show through. Paint the prismatic reflections on the vase with descriptive, angular strokes of yellow ocher and violet. Use violet on the pitcher and when dry, paint emerald green and violet on the bottle. Paint the shadows on the table with violet.

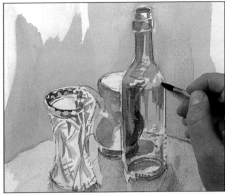

3 When the paint is dry, build up the final layer. Strengthen the ultramarine on the pitcher. Paint the detail on the bottle with a mix of ultramarine and viridian; when dry, give an allover pale green wash to unify the form.

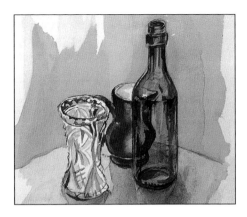

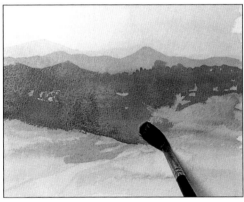

1 Flat washes have been laid over the whole of the hill area and allowed to dry before a darker glaze is applied over the nearer hill. The artist works quickly, sweeping a loaded brush from left to right.

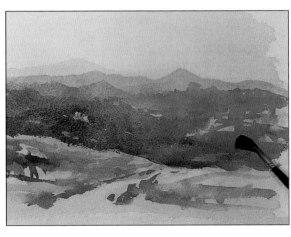

2 With the foreground complete, the hills seemed too pale to provide contrast, so the area was again glazed, this time with a touch of green mixed into the blue-gray used previously.

Underdrawing

For anything but very rapid sketches, it is important to make a pencil underdrawing before painting; this is a way of planning the composition, as well as making sure that the shapes and proportions are correct.

If you use a fairly hard pencil, such as HB or B, and keep the lines light, the paint will cover them, but some artists like to incorporate the drawn lines into the composition and make a heavier, more positive drawing. Whichever approach you take, draw outlines only, avoiding any shading. If you need to erase the drawing, make sure that you brush off any small bits of eraser left on the surface; otherwise the paint will pick these bits up.

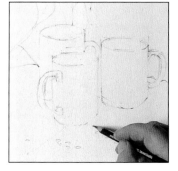

1 The artist is using a sharp but soft pencil (4B) for the drawing. Soft pencils are easier to erase than harder ones such as HB, but the choice is largely a personal one.

2 Here you can see the importance of the drawing. In a subject like this it is essential to plan the background wash and to take it carefully around the edges.

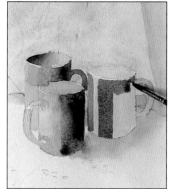

3 Again, the outline drawing helps the artist place the bands of dark and light color that show the forms of the mugs.

Underpainting

In watercolor work, underpainting serves several functions. First of all, if you take a pale wash right across the picture area, it allows you to create a toned ground on which to work in exactly the shade you want.

Second, because this toned ground shows through subsequent layers of paint—especially if you leave small areas uncovered—it helps to unify the various elements in your picture into a coherent whole. Third, it allows you to build up darker colors with fewer washes, thus avoiding the risk of muddying or overworking the picture.

1 Take a pale wash of alizarin crimson right across the picture area. Then lay loose washes of French ultramarine and Payne's gray for the sky, and olive green and gray for the water. When dry, block in the silhouettes of the docks with a deeper wash of Payne's gray.

2 Using cadmium red, paint a horizontal band along the waterline and add touches of the same color to the large crane. When dry, block in some detail in the docks with a glaze of yellow ocher and burnt sienna. Take another wash across the sky.

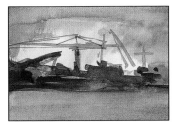

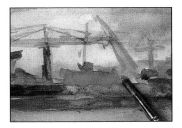

3 Before the sky is dry, apply some concentrated yellow ocher to the docks, allowing the color to bleed into the still-wet sky. Then apply more diluted yellow ocher into the water below for the reflection of the docks.

4 When the yellow ocher is still slightly damp, apply horizontal stripes of concentrated Payne's gray to the foreground of the docks. Apply a pale wash of Payne's gray to the water, allowing the underlying yellow ocher to show through.

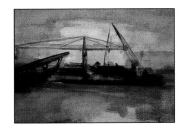

Expressive Brushmarks

Be aware of the emotional impact of the lines and strokes in your painting and try to choose those that are compatible with the mood you want to capture.

To help you loosen up before starting a painting, make random brushstrokes like the ones shown here and consider what emotions they convey.

HORIZONTAL

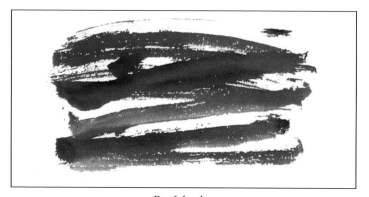

Restful, calm

RANDOM

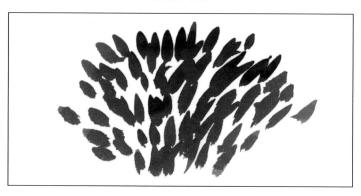

Energetic

UNDULATING

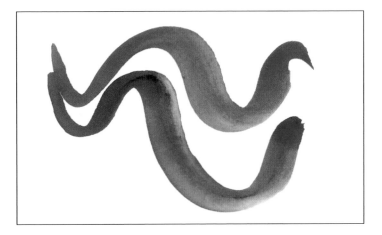

Tranquil, gentle

DIAGONAL

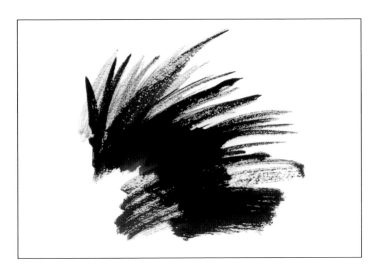

Spontaneous, dramatic

Using Expressive Brushmarks

The difference between a photograph and a painting is that a painting expresses more than just the surface appearance of things. With each stroke of the brush, the artist expresses his own personality and feelings about the subject. This is particularly evident in a watercolor painting, where every brushmark remains visible and therefore becomes an integral part of the finished image.

Beginners, though, have a tendency to be rigid and inflexible in their brushwork because they lack the confidence to be able to let go and adapt to the spontaneous qualities of watercolor. One answer is to break loose from the subject and let the enjoyment of it come through in the painting.

Looking at *Environs of Pamajera #39* (opposite), the word that springs immediately to mind is "exuberance." The artist, Alex McKibbin, reacts not merely to the outward appearance of trees, rocks, and water but to the pulse and energy they contain. Every inch of the painting is alive and vibrant. With his sweeping and fluid brushstrokes, McKibbin makes one feel the energy of the wind in the trees and the water rushing over the rocks.

To get more expressive power into your paintings, it's vital to put more energy into the brushstrokes. Remember those movement classes at school, when you had to pretend to be a tree swaying in the wind or a wave crashing on the shore? Embarrassed giggles all around. But you have to get into a similar frame of mind when you're painting: A tree grows upward and outward as it reaches for the light, so follow that movement with your brush, sweeping upward from the base of the trunk. Clouds billow and puff, water gently quivers, rocks tumble haphazardly toward the shore. If you can capture the inherent dynamics of nature with your brushstrokes, your paintings will have more life, more energy, and more emotional impact.

Achieving this energy and spontaneity without losing control of the medium requires skill, and this can only be gained through practice. Follow the example of Alex McKibbin, who likes to paint the same subject many times so as to become really familiar with it. The more he paints, the more he gets the feel of the subject and the freer and looser his brushstrokes become.

Downward, sweeping strokes propel the eye to the waterfall.

Energetic brushstrokes convey movement in the trees.

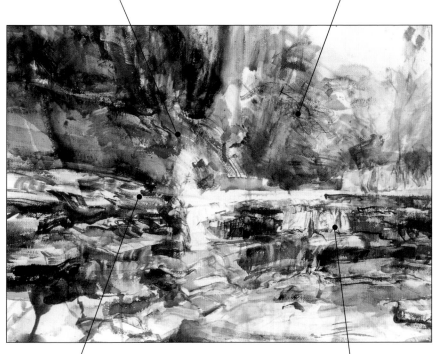

ENVIRONS OF PAMAJERA #39 by Alex McKibbin

Loose, dry brushstrokes allow the picture to fade out at the edges, concentrating attention on the waterfall—the focal point.

Transparent glazes of violet, blue, yellow, and green are used throughout, helping to tie the whole painting together through color harmony.

Learning to paint is a bit like learning to drive a car. The ride may be a bit bumpy and jolting at first, but the more you do it, the smoother it becomes.

Spattering

Spattering is an excellent way of conveying texture in a watercolor. You can use it to convey, for example, the densely spotted appearance of seaweed on a beach, the rough surface of brick or stone, or a mass of foliage dappled with light and shade.

The technique can be further enhanced by spattering on masking fluid as well as paint. This allows you to build up spatter with a larger number of colors while retaining the crispness of the individual marks.

To create a sense of perspective, spatter from the bottom up, as the brush will be more heavily loaded in the beginning and will make larger marks.

SPATTERING WITH A MASK

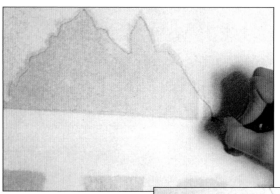

1 When spattering with a mask, the artist uses detail paper to trace the area he wants to mask.

2 The mask is then carefully cut with a scalpel.

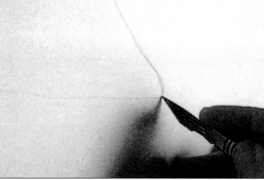

3 The mask is applied and the tree is painted in sap green, mixed with a little gum water to give it extra body and brilliance.

4 More sap green, again mixed with gum water, is spattered on the area with an ordinary household brush.

5 The slightly irregular, stippled effect is clear even before the mask is peeled off.

6 The mask is removed, leaving a sharp, clean outline. The slightly irregular texture is very effective in suggesting foliage.

Stippling

Stippling dots or flecks of two or more colors side by side onto a surface creates the optical illusion of a third color — the eye literally mixes the dots of color and perceives a third shade, a phenomenon exploited by such painters as the Impressionists and by the pointillist master Georges Seurat.

More simply, stippling is a way of conveying a particular kind of speckled surface texture, such as that seen on the roughened surface of the dirt road and the foliage in this picture. The wetness or dryness of the paint is crucial in determining the type of effect achieved — the drier you work, the more distinct the stippled marks you will make.

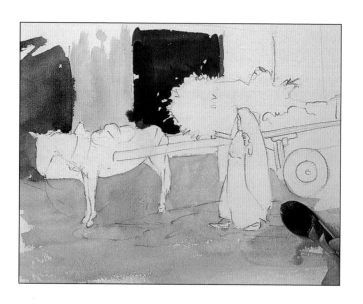

1 Lay flat washes of black, cerulean blue, and burnt umber on the doorways and wall in the background. Paint the dirt road with a wash of burnt sienna, avoiding the woman, donkey, and cart.

2 Paint the donkey and cart with a wash of burnt umber. Paint the vegetation sap green, and while still wet, drop in a little black for the shaded areas. Use the same method for the woman's clothing, applying a pale wash of indigo and adding in streaks of black.

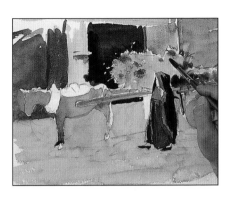

3 Paint the shadows on the donkey with a mixture of black and burnt umber. Use burnt umber and burnt sienna for the shadows on the ground. Use this same mixture, fairly wet, and a decorator's brush to stipple the texture of the road.

4 Still using the decorator's brush, stipple a fairly wet solution of viridian onto the vegetation. When dry, stipple on a dense, almost dry mixture of sap green and black. Complete the detail of the painting with a few extra brushmarks.

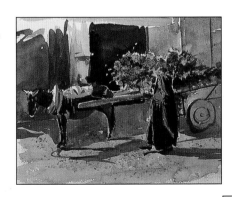

Scumbling

Scumbling involves scrubbing dry paint unevenly over another layer of dry color so that the first layer shows through in parts.

It is most often used in oil painting, but is well suited to acrylic and gouache, too. It is less suited to watercolor, but by using the paint as dry and thick as possible you can adapt the technique to this medium. With acrylic and gouache, which are more opaque than watercolor, there is no standard set of rules for application — you can scumble light over dark, dark over light, or a vivid color over a contrasting one. Because of the watercolor's natural translucency, however, it's best to adhere to the traditional sequence of working from light to dark.

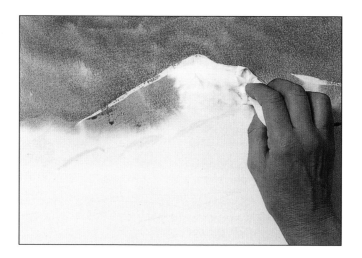

1 Mask the edge of the mountain with masking fluid and leave to dry. Dampen the paper and lay a wash of Antwerp blue mixed with a little Payne's gray. Lift out the color with tissue paper where it floods over the mountaintop. Work in more color to achieve the required density.

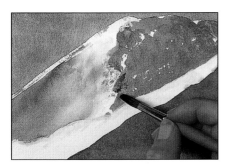

2 Paint the shadows on the mountain with a darker, grayer mix of the two colors used previously. Leave to dry, then using a twisting movement, scumble dry sepia on the exposed rack edges and peppered snow in the center.

3 Using a diluted but dry mixture of Antwerp blue and Payne's gray, scumble the trampled snow in the foreground. Build up tone in this way, patting and twisting the brush head as you go.

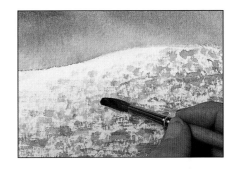

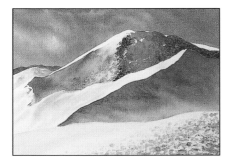

4 Carefully rub off the masking fluid. Dampen the white areas and drop in a pale wash of Antwerp blue for the shadows in the undulating snow.

Blots

Building up a painting from a random arrangement of paint blots is an experimental technique, excellent for loosening up the way you work and providing new visual ideas.

Like backruns, blot painting is unpredictable, and the shapes produced will often suggest an image or a particular treatment of a subject that you had not thought of before. Allowing a painting to evolve in this way can have a liberating effect and lead to new, more innovative ways of working.

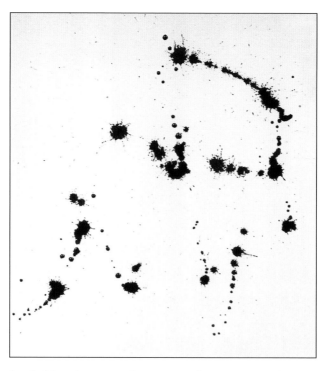

1 Flick a loaded brush onto a clean piece of paper to produce a random set of paint blots.

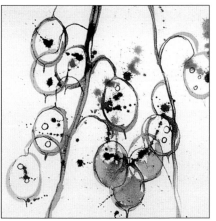

2 Look at the shape and placement of the blots to see what they suggest—here, they might suggest the seeds of the honesty plant (*Lunaria biennis*). Use a fine brush to outline the main shapes, then begin to lay washes to give some solidity to the forms.

3 Build up the color so that you achieve a balance of lights and darks and complementary tones. Additional blots of color may be dabbed on, as necessary, with a finger.

4 Avoid overworking the painting. Stop when you have added sufficient line and color to define the image so that it may be viewed figuratively, but before the spontaneity of the original technique is lost in a welter of detail.

Line and Wash

In the early days of watercolor, the paint was sometimes used merely to add color to a pen and ink drawing, but the method later developed into a more integrated approach, where the lines and colors complement one another.

Most contemporary artists regard the "colored-in drawing" effect as undesirable, and some will work with water-soluble ink, using this and watercolor washes hand in hand so that the wet paint softens the line in places. In general, it is best to avoid starting with a complete pen drawing; instead, begin with some lines and then colors, and add to both as the work progresses. You can even leave the linear drawing to the final stages, using it to add a touch of definition to an almost-complete painting. For this approach, you may achieve a less obtrusive effect if you use a dip pen with a strong solution of watercolor rather than black ink, which may stand out more strongly than you wish.

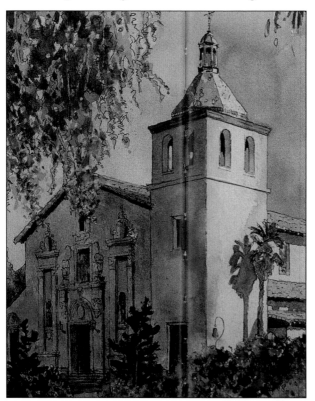

MISSION SANTA CLARA
by Claire Schroeven Verbiest

1 For a complex subject like this, it is wise to begin with a pencil underdrawing. Once you begin to use the pen and ink, you will not be able to erase.

2 Using a fine, fiber-tip drawing pen, the artist sketches in the scene. He fills in the dark areas as solid black because watercolor can't produce this strength of tone.

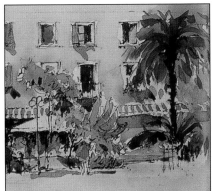

3 The watercolor is applied loosely over the lines using a large, well-loaded brush.

4 The advantage of this technique is that the pen and ink work provides the basic drawing and structure, as well as much of the detail, enabling one to paint freely.

Sponge Painting

A sponge is an important part of the artist's toolbox. It can be used both to blot up excess color and to apply color when a mottled effect is desired, as in the foliage of the two trees shown here.

Sponge painting can even be used to apply overall washes. The marks it makes, however, are not precise enough for intricate work or fine detail, and here a brush needs to be employed. Small artists' sponges are available, but you can improvise and cut a piece off a larger sponge. Always use natural sponges for painting, as they are more absorbent and pliable and, with irregularly spaced holes, produce a more pleasing, organic pattern than a harsh, synthetic sponge.

TIP
FOR A PROFESSIONAL RESULT

• Use a different sponge for different colors or wash your sponge out thoroughly between applications.

1 Begin sponging on yellow, orange, and green for the sunlit areas of the foliage. To preserve the crispness of the marks and to keep them from spreading and softening, always sponge onto dry paper. Continue adding color until you have the desired shape for the canopy of each tree. Leave to dry so that there is no muddying of subsequent colors.

2 Using a brush, paint in the trunks and branches. Paint in a loose band of color 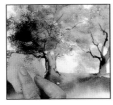 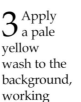 along the bottom to indicate the ground. Now sponge on darker, cooler tones, such as indigo and Prussian blue, for the shadowed foliage. Leave to dry slightly.

3 Apply a pale yellow wash to the background, working 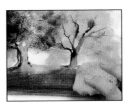 from right to left and light to dark and allowing the wash to pick up some of the sponged color in the foliage. Using the sponge, apply a band of French ultramarine across the foreground.

4 For extra definition, dab on more dark tones with the sponge. Where the sponge is too unwieldy, use a brush to apply these darks.

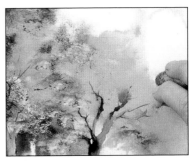

5 Finally, dab on white body color for the lightest foliage on the left. (A damp sponge can also be used to scrub out highlights.)

6 The limited palette of yellow, orange, brown, and blue gives the finished piece overall cohesion. Note the careful balance between shadows on the left and highlights on the right, which avoids a confused mass of tones.

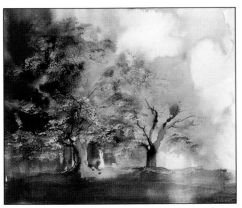

Using Masking Fluid

Small, fussy highlights that are awkward to paint around can be preserved by covering them with masking fluid prior to painting.

Masking fluid is a rubbery liquid solution sold in small bottles. Simply apply the fluid with a brush over the areas that are to remain white. It dries very quickly to form a waterproof seal, allowing you to apply washes freely over the paper without having to carefully avoid the white shapes. When the painting is completely dry, the mask is easily removed by rubbing it off with your finger or with the corner of a clean eraser. Never allow masking fluid to dry on your brush, as it will ruin it. Wash the brush in warm, soapy water immediately after use to prevent the rubber solution from drying hard and clogging up the bristles. It is a good idea to keep an old brush handy for applying masking fluid, or buy a cheap synthetic one especially for this purpose.

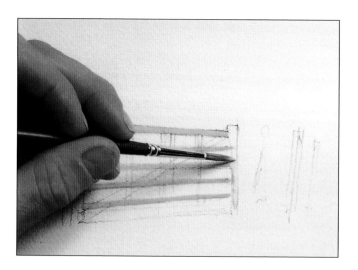

1 Apply masking fluid to the parts you wish to protect. If you use tinted fluid, it will be much easier to see where you have applied it. For more hard-edged, linear masking, apply the fluid with an old nib pen. Softer-edged areas can be masked out with a brush.

2 When the masking is thoroughly dry, start to build up the washes. The color can be brushed freely over the dry masking fluid, which acts as a waterproof barrier to protect the paper underneath.

3 When all the paint is dry, gently rub off the masking fluid to reveal the white shapes. When removing the dry fluid, be careful not to tear the paper underneath.

4 Apply color, as desired, to the previously masked areas.

Lifting Out

Another method of creating highlights is by gently lifting out color from a wash while it is still wet, using a brush, sponge, or tissue.

Whereas masking fluid creates hard-edged highlights, lifting out creates softer, more diffused highlights, suitable when painting natural forms such as clouds, fruits, and flowers.

It is also possible to lift out color when the painting is completely dry. For soft highlights, try gently scrubbing off color with a wet brush, a tissue, or a cotton swab. For sharper, more linear highlights, use a sharp-edged tool such as a knife or a wooden toothpick. It is said that Turner sharpened his thumbnail into a point for scratching out highlights.

A final alternative is to use white gouache paint (an opaque form of watercolor) to add highlights to the finished painting. This can look clumsy and rather obvious, however, and should be used with restraint.

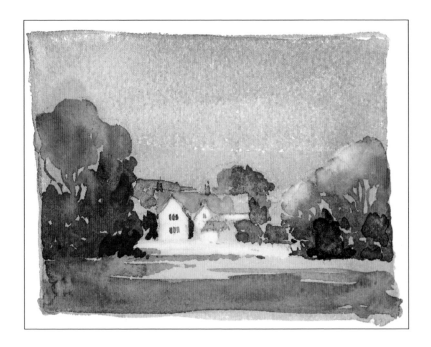

A Lifting out color with a tissue creates a soft effect.

B A cotton swab is useful for lifting out small, linear shapes.

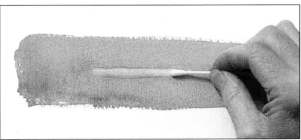

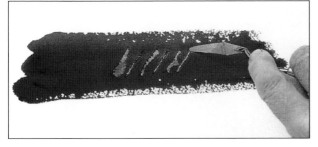

C A sharp scrape at a slightly damp area gives textured effects.

Opposite page: Once this painting was dry, color was lifted out in parts of the central area to produce a sparkle of light. This area of high tonal value forms the focal point of the painting.

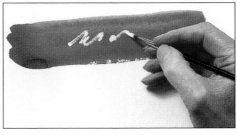

D An alternative to lifting out is to paint over a dry area with opaque white body color.

Scraping Back

Scraping back, or sgraffito, simply means removing dry or just-damp paint after it has been applied.

The technique is most useful for creating the kind of small, fine highlights that cannot be reserved, for example, when the light catches the blades of grass in a landscape. Almost anything can be used for scraping back provided it works, from a round-bladed craft knife to such unusual implements as credit cards, fingernails, and sandpaper, all of which produce different results. It is important to judge the dampness of the paint before you begin. If too wet, the color will flow back into the space it formerly filled, and the damp paper underneath might tear; if the paint is dry, it can be difficult to scrape away. The only exception to this last rule is sandpaper, which should not be used unless the paint is thoroughly dry.

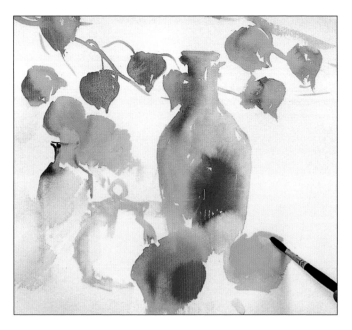

1 Begin building up the picture with washes of color. This light underpainting provides a base to scrape back into.

2 When you have built up sufficient tone, start to scrape back, using whatever tools you wish. A credit card, for example, creates a neat edge. When scraping back, the paint should be just damp, but not too wet.

3 To suggest the effect of shafts of light, fold some sandpaper to a sharp edge and use it to rub the paint.

4 Using a selection of different tools to scrape back the color can create many different effects in the same painting, for example, the gleaming highlights on the bottle, the crisp edges of the leaves, and the shafts of light in the background.

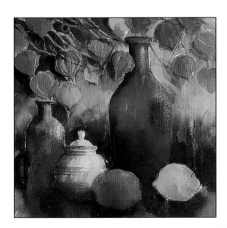

Washing Off

Washing off is a technique in which paint is applied to paper and then held under running water so that only some of the color remains, leaving other parts subtly stained with pigment.

Some colors, such as phthalo blue and green, have greater staining power than others (check this with the manufacturer). For those marks or outlines that you wish to retain, a useful trick is to draw them with a sharpened twig or similar instrument, loaded with paint or ink. This scratches a groove in the paper where the color settles and is not so susceptible to washing. Naturally, the paper you use must be thick or still stretched on its board to withstand the water treatment. Care is also needed as to when the paint is ready for washing — if still too wet, it may all be removed; if too dry, it may be impervious.

1 Build up tones, working wet-on-wet. Special effects can be applied at this stage. For example, dropping methylated spirits or sprinkling salt into selected areas disturbs the surface color and creates a spotty texture.

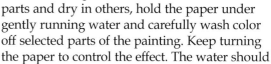

2 When the paint is still damp in parts and dry in others, hold the paper under gently running water and carefully wash color off selected parts of the painting. Keep turning the paper to control the effect. The water should be little more than a trickle — too fierce a current would wash off too much color.

3 Leave the painting to dry and assess where you need to intensify any colors that are too washed out or where outlines or shadows need strengthening to give definition to the image. Note the delicate staining on the vase.

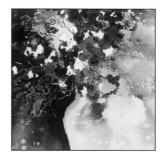

Wax Resist

Wherever wax is applied to paper, its greasy surface repels watercolor, resulting in an unpredictable, speckled pattern that is ideal for conveying natural textures.

A white wax crayon or white candle can be used. Waxing directly onto white paper will reserve the whiteness and is therefore good for creating highlights. If you want to achieve a colored texture, you need to lay a wash of color first, allowing it to dry before scrubbing on the wax. Think, too, about the textures you are representing—circular wax scribbles suit foliage, while more jagged, linear ones better convey the pattern of tree bark or ripples on water.

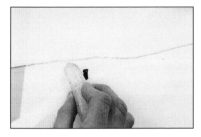

1 After the preliminary drawing, make masks of torn paper to mask out the banks of the stream—a torn paper edge provides a much more natural line than a cut one. Holding the masks in place, scrub a white candle across the stream.

2 Remove the masks and dampen the paper above and below the stream. Scrub the candle over the river and where the foliage of the tree is going to be. While still damp, lay loose washes of color for the banks, the path, and the sunlit foliage. Leave to dry.

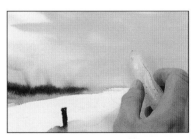

3 Apply a wash of green over the waxed area of the tree. Allow this to dry, then paint in the trunk and branches. Wax again and apply the same green to the foliage, but darker and drier this time. Wash a dark blue wash over the stream—if you have waxed this sufficiently, all you will get is a spattering of color. To finish, paint in the fence posts, the bushes, and the shadows on the path and banks.

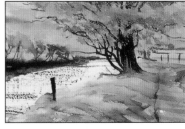

Mixing Media

Many other media can be used in combination with watercolor; indeed, the mixing of media is now commonplace, whereas in the past it was regarded as breaking the rules.

Watercolor used with pen and ink has a long history; in the days before watercolor became recognized as a medium in its own right, it was used mainly to give touches of color to drawings or to tint black-and-white engravings. Today there are many other media—some old and some new—that can be used with watercolor to good effect.

One traditional way to change the nature of paint by thickening it is to mix it with a little gum arabic, which gives it both texture and lasting luster. Soap can also be used to make imprints of objects such as leaves or flowers. Coat the object with soap, apply paint to it, and then press it onto the paper.

Watercolors can be drawn into with pens, pencils, crayons, or pastels, and areas can be stressed or lightened with gouache or Chinese white. Watercolor pencils and crayons, a relatively new invention, are particularly suitable for this purpose. When dry they behave like crayons or hard pastels, but if dipped in water or used on wet paper, they will dissolve, forming a wash. Using these or ordinary pastels on top of watercolor can turn a painting that has become dull and lifeless into something quite new and different. It is always worth experimenting with such media on a painting that you are less than happy with; you may discover a personal technique that you can use again. Wax oil pastels can create interesting textured areas when laid underneath a wash, as can treating the paper, or parts of it, with white spirit before painting, which has a similar effect. The possibilities are almost endless, and experimentation is sure to reward you with interesting discoveries.

Oil pastel can also be combined with watercolor, but remember that oil and water do not mix, so if you try to lay watercolor over oil pastel, it will slide off. This can be very effective, provided you know what you are doing and plan the painting accordingly. Because there are no fixed rules, any mixed-media work requires practice and a period of trial and error, so you might find it helpful to use a failed watercolor as a test or simply doodle to try out different ideas.

WATERCOLOR AND OIL PASTEL

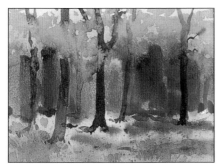

1 Watercolor is to be combined with pastel for this woodland landscape. Because watercolor is a wet medium and pastel a dry one, the painting is done first and allowed to dry.

2 The darker colors are allowed to stand as pure watercolor, with the pastel used mainly for the highlights and to provide accents of color in the foliage.

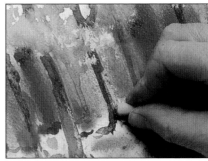

3 The artist wants to draw the eye toward this area of the painting, and lays pale mauve pastel over the darker watercolor to suggest distant tree trunks.

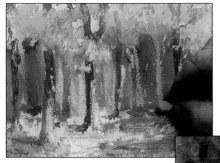

• TECHNIQUES •

ONIONS by Keith Andrew
For this powerful painting,
watercolor and gouache are
combined so that thick, opaque
paint contrasts with fluid,
transparent washes.

Making Changes

Although watercolors cannot be altered so drastically or soften as paintings in any of the opaque media, changes are possible. It is a mistake to abandon a picture because a first wash has gone wrong.

The first thing to remember is that a wash that looks too dark or too vivid on a sheet of otherwise white paper will dry much lighter and may look quite pale when surrounded by other colors. If the first wash looks wrong, let it dry. If you are still quite sure it is not what you intended, sponge it out with a clean sponge and clear water. This may leave a slight stain on the paper, depending on the paper used and the color itself (some colors stain the paper, like a dye, while others do not), but when dry it will be too faint to spoil the new wash. When a wash has flooded, sponge it out immediately without waiting for it to dry; flooding cannot be entirely remedied, though it can sometimes create an effect not originally planned.

One of the most common faults is to accidentally take a wash over the edge of an area to be reserved. There are three ways of dealing with this, depending on the size of the area and the type of edge desired. If the wash is pale and the area to be reserved is a broad and imprecise shape, such as a stone in the foreground of a landscape, you can simply sponge out the excess paint with a small sponge or cotton ball dampened in clean water. A soft edge will be left. For a more intricate shape or one requiring a sharp, clear edge, you may have to scrape the paint away (after it is dry) with a razor blade or scalpel, the former for broad areas, the latter for small ones. Hold the blade flat on the paper so that the corners do not dig in and scrape gently. The same method can be used to lighten an area or to create texture by removing a top layer of paint. The third rescue technique—to apply Chinese white with a fine brush—should be used only when the painting is otherwise complete; if the white is allowed to mix with other colors, it will muddy them and spoil the translucency.

The small blots and smudges that often occur when you take a loaded brush over a painting or rest your hand on a still-damp area can also be razored out when dry. If a splash of paint or dirty water falls on the painting, quickly soak up the excess with a twist of tissue or a cotton swab, let it dry, and then scrape it out gently. If you are intending to apply more paint to the area, rub it down lightly with a soft eraser to smooth the surface.

Even professionals sometimes find that a painting has gone so wrong that small corrections will not suffice or has become so clogged with paint that further work is impossible. If this happens, you can throw it away or you can wash out the whole painting (or large parts of it) by putting the paper under running water and sponging the surface. Leave it on its board if you have stretched it. A slight stain may be left, and its faint shadow will serve as a drawing for the next attempt. A whole sky or foreground can be removed in this way, while leaving intact those areas with which you are satisfied.

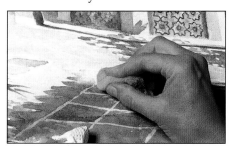

1 This painting was almost finished when the artist decided that a shadow in the foreground was too angular and hard-edged. She washed down the edge with a sponge dipped in clean water—you can see how the edge is already starting to soften.

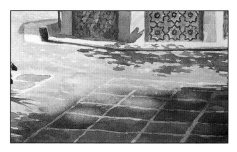

2 Successfully softening the shadow meant that there was now insufficient differentiation between light and dark areas.

3 When the softened area was completely dry, the artist applied a little more of the original color to the rear of the shadow to create an irregular edge similar to that below the fountain and left this to dry. Then, using body color matched to the paving—white gouache mixed with alizarin crimson—she created patches of dappled light within the blue shadow.

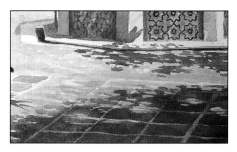

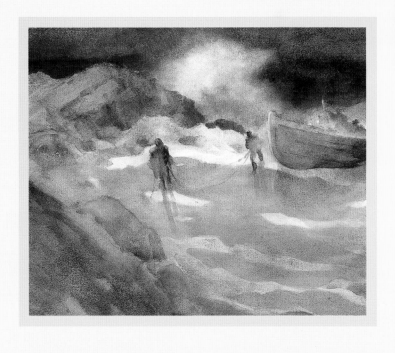

COLOR AND COMPOSITION

Good composition means selecting the shapes, colors, and values in your picture and then arranging them so that they balance beautifully within the borders of the frame. Although this process quickly becomes instinctive as you gain experience, there are several basic rules to get you thinking along the right lines. It is worth knowing the rules as you learn, but your paintings need not follow a formula.

Professional artists tend to distrust "rules" about composition, arguing that every master painter has broken every rule at one time or another. But you can only break the rules successfully once you know what they are, so keep the guidelines described here in the back of your mind until your compositional sense has had a chance to develop. Later, you will know automatically what makes a picture work and you will then be able to start experimenting with more unorthodox ideas.

Creating a Focal Point

A picture should ideally have one focal point — an area to which the eye is naturally drawn and thus forms a resting place.

Without it, the viewer's eye wanders around the picture without knowing where to linger. It is important to consider where the focal point will be before you start painting; once this is decided, the rest of the composition can be arranged around it.

A good way to draw attention to the focal point is by reserving the strongest contrasts for that area — light against dark, warm against cool, bright against neutral, large against small. You may have secondary points of interest, but make sure they don't compete for attention with the main focal point.

THE RULE OF THIRDS

It might seem logical to place the focal point in the middle of the picture, but in fact that appears static and boring because it divides the picture area into two equal parts. To produce a balanced, satisfying composition, try using the rule of thirds. Divide your layout into thirds vertically and horizontally. The intersection of the thirds produces four ideal

Before starting your sketch, try drawing a grid like this one above, dividing the area into thirds horizontally and vertically. Use one of the horizontal lines to place the horizon. Then use a vertical line to help place the focal point of the picture, as in this sketch.

positions for the center of interest. Placing it off-center often creates a more dynamic image than one with a central emphasis.

Troubleshooting

This landscape lacks dramatic interest. Should it have been composed differently?

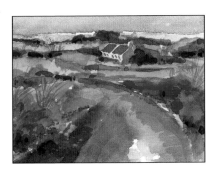

THE PROBLEM

James McNeill Whistler (1834–1903) was right when he said, "Seldom does Nature succeed in producing a picture." What he meant was that a scene that is breathtaking to the naked eye may appear less exciting when translated into paint on a small square of paper. Often, it isn't enough simply to copy the subject in front of you; sometimes you may have to add, subtract, or regroup some of the elements in the scene in order to create a more balanced image.

The problem with the landscape above is that it has no main focal point, nothing that says, "This is why I wanted to paint this scene." The road leads our eye into the painting, but then it turns sharp left and leads us straight out again. The cottage in the distance could have been the center of interest, but it doesn't stand out strongly enough. There is nowhere for the eye to stop and linger, so the picture is like a sentence without a period.

THE SOLUTION

Just as a play or film often has one main character and a supporting cast, so a picture should have one focal point—that is, one spot that draws the eye and carries the main theme of the painting—supported by shapes and colors of secondary interest. This is what gives balance and unity to the painting.

In *Road to the Sea* (page 88) note how artist Stan Perrott has made slight alterations to the composition and to the tones and colors in the scene in order to make a stronger image. The cottage in the distance is now firmly the focal point. Why? Because it is here that the lightest and darkest tones in the painting are juxtaposed—and the viewer's eye is always attracted by such a strong contrast. The sweeping curve of the road also leads us to the center of interest instead of veering off out of the picture.

When planning the composition of a painting, always ask, "What needs to be emphasized, and how should this be done?" There are many ways to draw attention to the focal point, but they all have one thing in common: they involve the use of contrast to generate excitement in that area.

Choosing the focal point of your painting and planning ways to accentuate it are the keys to a good design.

Harmonious colors and tones give clarity and strength to the image.

The contrast of the darkest and lightest tones attracts the eye and forms the focal point of the picture.

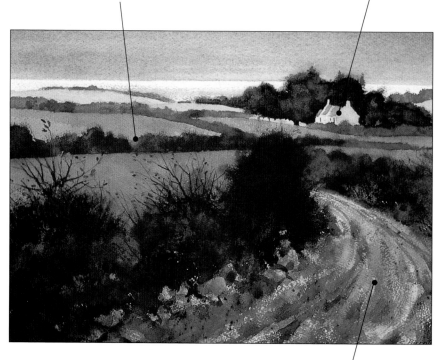

ROAD TO THE SEA by Stan Perrott

The light tone of the road leads the eye to the focal point.

Placing the Horizon

In landscapes, deciding where to place the horizon is an important way to give emphasis to your subject and to balance the composition as a whole.

Placing the horizon in the center of the picture is not advisable. Like a centered subject, it has the effect of dividing the composition in two, leaving the eye undecided as to where to go. To give your pictures more visual impact, try placing the horizon either above or below the center. For example, if you want to emphasize a dramatic sky, place the horizon line low down in the picture space.

• COLOR AND COMPOSITION •

A low horizon line emphasizes the sky area and helps to create the illusion of space and distance.

Here you can see the low horizon principle employed in a quick color sketch.

Another test sketch to try out a composition idea using the principle of the rule of thirds. Notice where the horizon and trees are placed.

89

Perspective

Most people draw what they know rather than what they see. It is important, therefore, to try and forget conventions and your preconceptions of the world and things in it and better to examine the subject you are concerned with, be it landscape, portrait, or still life, and pretend you are faced with something new and strange that you have never seen before.

It is a mistake to try and paint from memory, spending more time concerned with your watercolor than with the subject itself. Spend as much, if not more, time looking at your subject and making mental notes of its relationship to other objects. Hold your brush or pencil at arm's length, shut one eye, and examine what your eye tells you to be the horizontal or vertical lines. More often than not, you will find that you have misinterpreted what you have seen at first glance; outlines of diminishing objects form subtle angles from the horizontal and vertical and need to be checked. In painting, you are attempting to transpose three-dimensional objects onto a vertical, two-dimensional plane (your picture) in a realistic and convincing way. In order to be able to do this, you must understand some general rules.

THE BASIC RULES OF PERSPECTIVE

The ground on which you stand is known as the ground plane. If the ground plane were completely flat, that is, if you were standing on a beach and overlooking the sea or painting a Dutch landscape, you would be able to see where the sea or ground met the sky. The ground plane meets the sky where the curvature of the earth prevents us from seeing it stretching out before us. It often happens that hills, houses, trees, or other obstructions prevent us from seeing this far.

The horizon line occurs at eye level. If you were standing on a flat plane you would be able to test this by holding a sheet of paper or a ruler up to your eye level and finding that this matches up with the horizon line. The support on which you are drawing or painting is called the picture plane. By drawing in the horizon line you can establish your vanishing points. These are imaginary points where parallel lines appear to meet. A straight road or a railway line, for example, will appear to converge into a dot on the horizon.

One-, two-, and three-point perspective are three commonly used systems (see diagrams) and there are many more unusual

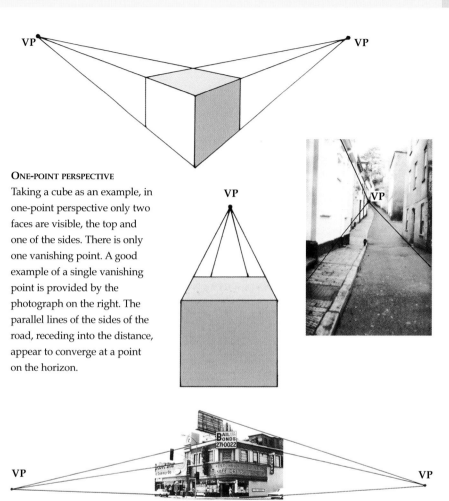

ONE-POINT PERSPECTIVE

Taking a cube as an example, in one-point perspective only two faces are visible, the top and one of the sides. There is only one vanishing point. A good example of a single vanishing point is provided by the photograph on the right. The parallel lines of the sides of the road, receding into the distance, appear to converge at a point on the horizon.

systems, such as cylindrical or spherical perspective. Other painters have adhered to totally different systems from those that evolved from western European art. Egyptian art used scale to suggest distance, making distant objects smaller and placing them higher in the picture. Chinese, Persian, and

TWO-POINT PERSPECTIVE

Here, three planes of the cube are visible—the top and two of the sides—so there are two sets of receding parallel lines and two vanishing points. The photograph of a street corner (above) is a good example of two-point perspective, the two sets of lines from the tops of the buildings and the sidewalk converging at two vanishing points.

Indian art are also examples of widely differing systems used to convey distance and space. Within Western art, some people have made pictures without following the conventions, either by showing parallel lines to be parallel or, frequently, by using systems very much akin to Egyptian or Chinese methods. Other artists have deliberately chosen to ignore these systems and contorted our perspective rules to change our ideas of space and shapes within that space.

Many artists have made drawing aids to help them understand perspective. Canaletto (1697–1768) used a camera obscura that projected his subject matter onto a sheet of paper or glass so that it could be traced off. Dürer (1471–1528) used a squared-up sheet of glass through which to view his subject and then translated this onto a squared-up sheet of paper. Try a similar method by tracing what you see onto a window, being careful not to change the viewpoint. By joining up the vanishing points it may be easier to understand perspective, but these methods should really only be used as exercises. They have a tendency to go to the extreme of making one too aware of perspective and can give the picture a stilted appearance.

THREE-POINT PERSPECTIVE
Three planes of the cube are again visible, but there are three, not two, sets of converging lines and three vanishing points. This happens when the cube is viewed either from very far above, as in the diagram (far left), or from below (left), so that the vertical lines also converge.

VP

VP

VP

VP

VP

VP

VP

Measuring

It's common for simple but fundamental mistakes to go unnoticed until it is too late to make substantial changes, so try to get the drawing right before you begin to paint.

Your pencil can play a dual role. As well as drawing with it, you can use it to check angles and figure out the relative sizes of objects.

Hold the pencil at arm's length and slide your thumb up and down it to calculate the relative sizes of objects.

Hold up the wooden ruler and swivel it until it matches the diagonal, then transfer the line to the drawing.

Using and Making a Viewfinder

When we look through the viewfinder of a camera, we are using it to isolate an area of interest from the overall view. Once we are satisfied with the image seen through the viewfinder, we press the shutter and the scene is captured on film.

In a similar way, you can use a simple cardboard viewfinder to isolate a particular section of a scene you wish to paint. By framing the subject in this way, you can check to see that it makes a satisfying composition.

1 To make a viewfinder, use a strong piece of cardboard, about 8 x 10 in.

2 Cut out a central window measuring 4 x 6 in.

3 Close one eye and look through the frame. Move it toward and away from you, up and down, left and right, until the subject is framed in a pleasing way.

4 Now move the viewfinder so that the focal point rests on or near a point where two of the grid lines intersect.

You will be amazed to discover many more potential paintings in one scene than you had first imagined. Use your viewfinder constantly; you will find it an invaluable aid in finding and planning good picture ideas.

Directing the Eye

To capture and hold the attention of the viewer, try to design rhythmic lines and undercurrents that flow into the center of interest from the edges of the picture.

The composition presented by nature is not always ideal. The viewpoint must be chosen carefully and the artist must be prepared to alter the arrangement of things if necessary in the interests of making a more balanced and coherent image.

In *Farm in the Valley* (page 96), there is a similar scene to that in the problem painting below, with a tiny cottage nestling at the foot of the mountains. Only in this version the artist, Keith Andrew, has created an exciting composition guaranteed to hold the viewer's interest.

First, the focal point (the cottage) is placed just off center, at a point that is a different distance from each edge of the paper, thus creating balance without boredom. Note how everything is designed to lead the eye to the focal point: the mountains sweep downward from the top of the picture, while the river and the trees curve in from

This landscape is nicely painted, but it fails to excite any interest because it is too bland. To begin with, the focal point—the farmhouse—is placed slap in the middle of the picture, which is much too boring and symmetrical. And because there are no interesting

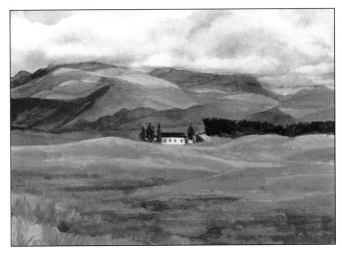

directional lines leading to the farmhouse, it looks lost and disjointed. The painting is composed of three horizontal bands: the sky, the mountains, and the foreground. These have the effect of carrying the eye right out of the picture, because there are no strong vertical shapes to counterbalance the horizontals.

the bottom right. Even the clouds are designed to lead the eye down to the mountains and on to the cottage. The impression of depth is much greater, too, because the curving lines take the viewer into the picture, not across it as happens in the problem painting. The whole picture is beautifully choreographed, yet the directional lines are subtle enough to guide the eye without being obtrusive.

The mountains form strong diagonal lines that propel the eye to the focal point.

An area of light tone against dark attracts attention and so forms the focal point of the picture.

The clouds pull the eye down into the painting.

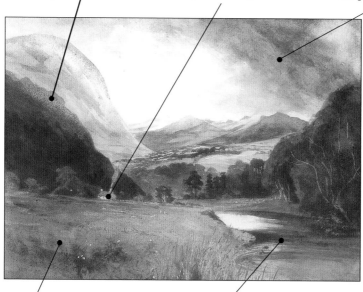

FARM IN THE VALLEY by Keith Andrew

This part of the painting contains less detail and provides a restful area in an otherwise active composition.

The river and trees curve in toward the focal point.

Right: The arrows show how the composition is arranged to create visual pathways leading from the edge of the picture to the focal point.

Tonal Values

Painters often get confused between the terms color and value. Value is the lightness or darkness of an area irrespective of its color.

The key to successful painting is understanding and controlling tonal values when the painting is planned; they are more important than color in organizing a composition, suggesting form and conveying a sense of depth.

In a black-and-white photograph there are no colors—only tonal values ranging from white, through various shades of gray, to black. Even so, it is quite clear what is going on because these values accurately portray the amount of light reflected by each object in the picture, enabling the eye to decipher what they are.

Although in nature there are an almost infinite number of tones between black and white, the naked eye is only capable of distinguishing between six and nine comfortably. In practice, this many tones are not needed; it is possible to produce a perfectly clear image using only five or six tones. By simplifying tones

A VALUE SCALE

1 **2** **3** **4** **5**

• A value scale like the one shown here is useful in gauging the values of the objects being painted. Simply give each area of color a tonal value from one to five on the scale, depending on how light or dark it is.

Start by drawing a row of five squares on a sheet of white paper. Leave square 1 as white paper. Fill in square 5, making it as black as you can by exerting pressure on the pencil. Now fill in squares 2, 3, and 4 with hatched lines, carefully grading them from light to medium to dark.

and grouping them together a strong and cohesive image can be created that makes an impact on the eye. If the tones are too many and too scattered, confusion results and the eye quickly becomes tired.

Before starting to paint, observe the chosen subject and establish the lightest light and the darkest dark. Then compare the relative tonal values between these two extremes. If it is difficult to distinguish the different tones, try screwing up your eyes until hardly anything can be seen through them. This eliminates most of the detail and color, enabling you to concentrate on tonal values more easily.

Look at the overall scene as well as individual areas and compare one tone in relation to another. How much darker is the foreground than the sky? Are the trees darker or lighter than the foreground? Once the main value masses are established correctly, it is much easier to develop the shapes and forms within them.

Get into the habit of making small tonal sketches as a means of organizing the distribution of tones. When the drawing is finished, there is a complete plan for a painting. One look at the drawing will show instantly, working from light to dark, the order in which the watercolor layers must be applied.

LAYERING OF VALUES

• Working from the lightest tonal values to the darkest, most paintings

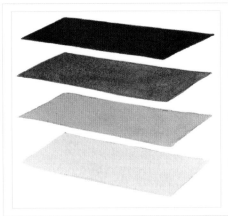

foreground

middle distance

distance

sky

can be completed in three or four layers, one applied over the other. The darkest values are usually found in the foreground, particularly in landscapes.

ATMOSPHERIC PERSPECTIVE

Due to the effects of atmosphere haze, objects in the distance appear lighter in tone than those close to us, and detail and contrast diminish. In order to create the illusion of space and distance in the landscape paintings, these effects should be reproduced by reserving the strongest tones and tonal contrasts for the foreground. As the artist moves toward the horizon, weaker tones should be used and the degree of detail and contrast should be reduced.

TONES AND COMPOSITION

The arrangement of lights and darks within the picture is an important aspect of composition. Passages of light or dark values create visual interest and help to move the viewer's eye through a painting. Strong value contrasts can create emphasis where it is needed in a picture because they tend to attract the eye and they should therefore be reserved for the center of interest.

TONE AND MOOD

There is a strong connection between the tonal range of a picture and the mood it conveys. A painting that consists primarily of the darker values in the range gives a somber and serious atmosphere, whereas a painting with a full range of tones, bright highlights, and crisp shadows creates a lively and cheerful impression. Think about how to orchestrate the tonal quality of the painting to illustrate the mood that is conveyed.

Above: The illusion of receding space is created in this landscape by keeping the distant colors pale and blue and the foreground colors darker and warmer.

Below: A low light source directly behind the subject produces lovely effects because the subject is thrown mostly into shadow, with just the outer contours brightly lit.

Tonal Contrast

"Tone" simply refers to how light or dark a color is. Every color, therefore, has a tone. Light, medium, and dark tones each have a different visual weight.

• WATERCOLOR HANDBOOK •

If a painting looks disjointed or weak, chances are the reason is not due to lack of color contrast but lack of tonal contrast. In order to create a strong and unified image, these visual weights must be carefully planned and distributed. Think of the colors (and therefore the tones) as the keys on a piano. Pressing a few carefully chosen keys will produce a rich, melodious sound. But if both hands are spread out and keys pressed at random, a discordant sound will be produced.

The landscape below strikes a discordant note because there is no organization to the pattern of lights and darks. Instead, the student has built up a patchwork of unrelated tones and colors that fight against each other and break up the unity of the picture. This is a common mistake made by beginners, who tend to copy the local color of each individual object and fail to see the harmonizing effects of light on the scene.

The allover pattern of lights and darks is the "skeleton" that holds a painting together. It takes some time for most beginners to understand this, but once the idea is grasped, their work improves enormously.

Stan Perrott's painting *Farm Near Totnes* (opposite) actually contains fewer colors than the problem painting below, yet its emotional impact is far greater.

The country scene is brought to life through the contrast of light against dark, rather than color against color. The image is composed of large masses of light, dark, and middle tones, giving the image strength and stability. Note, for example, how the dark tones of the land play against the pale tone of the

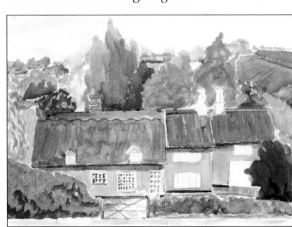

The colors and tones in the background trees are simplified to give strength and stability to the image.

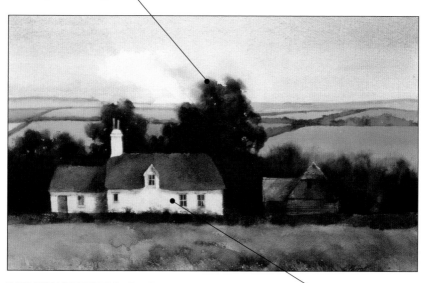

FARM NEAR TOTNES by Stan Perrott

Here the lightest and darkest tones provide dramatic impact, set against the middle tones in the rest of the painting.

sky, and the pale tone of the house contrasts with the dark trees behind. Compare this to the problem painting, in which the lack of tonal contrast makes the image seem weak and washed out, like an underdeveloped photograph.

TONAL MASSES

It's important to plan the tonal pattern of the subject before painting is started—especially in a watercolor, which must be worked up gradually from light to dark. It's a good idea to make a small tonal sketch of the scene to be painted, indicating the main areas of light, dark, and middle tones. Remember to group similar tones together into larger shapes—don't scatter small bits of tone all over the painting.

DOMINANCE

Try never to end up with a painting evenly divided between light and dark tones. Allow one or the other to dominate or use mainly middle tones with small areas of light and dark to give the image impact. Stan Perrott's painting, for instance, comprises mainly middle tones, with the dark shapes of the trees and the light shape of the house providing dramatic contrast.

Creating Mood

Often what inspires an artist to paint a particular subject is not so much the subject itself but the way the light falls on it. Capturing the effects of light and atmosphere in a scene will communicate a mood, thus inviting the viewer to share in a unique emotional experience.

In his first version of *Storm from the Sea* (below), artist Stan Perrott painted the scene more or less as he saw it on a dull, overcast day. The colors are subdued and the tonal range is basically medium, with few dramatic lights and darks. As a painting, it is perfectly acceptable, but the artist felt that it needed something to lift it out of the ordinary.

In the second version of *Storm from the Sea* (page 104), the composition is similar, yet the mood is very different. Here the artist uses a limited palette of cobalt blue, Payne's gray, and burnt sienna to create dark tones and colors that convey the brooding, scary atmosphere of an approaching storm. Note also how he has shifted his viewpoint slightly so that the dark shape of the cottage stands out against the light part of the sky. The clouds are now dark and menacing, and the white shapes of the seagulls add a final dramatic note.

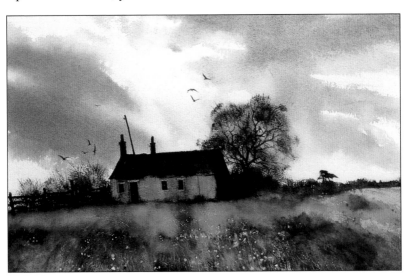

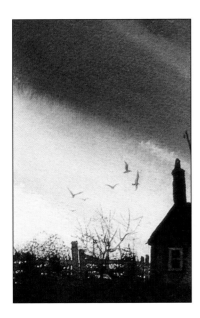

The seagulls are painted with masking fluid to preserve the white of the paper before applying the sky wash. When the paint has dried, the fluid is rubbed off to reveal the birds' delicate white shapes.

The cottage is outlined against the light part of the sky. Strong tonal contrasts here add impact. Dark, swirling clouds radiate from the center of the picture in a convincingly dramatic way.

PLAN THE MOOD

The key to capturing mood and atmosphere in a painting is careful planning. The main thing to make sure of is that the colors, tones, and linear design of the painting are all consistent with the mood to be conveyed. Begin by identifying the overall tonality of the scene. Is it soft and tranquil? Or light, bright, and breezy? Make sketches of the scene, if necessary, altering the composition and manipulating the tonal range until it looks right.

Cobalt blue, Payne's gray, and burnt sienna are used for the dark tones of the grass, textured with scumbled brushstrokes using a hog's hair brush.

TONAL VALUES

Controlling tonal values is particularly important because the relative amounts of light and dark in a painting have a strong influence on its emotional feel. Dark tones should predominate if a low-key, atmospheric mood is desired.

Let light tones predominate if a bright, high-key mood is desired. Always work within a limited tonal range. If there are equal amounts of light and dark in the painting, the emotional message will become dissipated.

STORM FROM THE SEA by Stan Perrott

BLACK JUMPER by Lucy Willis High-key colors and tones create a strong impression of bright sunlight in this delightful beach scene. The girl's dark sweater adds a note of contrast, which keeps the image from looking washed out.

Creating the Illusion of Depth

The greatest challenge in landscape painting is how to achieve an impression of the land and the sky stretching back toward the horizon, so that the viewer can mentally step into the picture.

To understand the effects of aerial perspective, it helps to imagine the landscape as having a series of transparent, bluish veils stretched across it every fifty feet or so. The farther back they can be seen, the more veils have to be looked through, making objects appear bluer in color and hazier in form the closer they are to the horizon.

The effects of aerial perspective can be clearly seen in Ronald Jesty's painting *Alpspitze* (page 106). Here the impression of space and depth is quite dramatic, and the whole scene is suffused with a palpable feeling of air and light.

SPATIAL PLANES

There are six distinct spatial planes in Jesty's landscape: the foreground field, the tree-covered hills, and then the serried ranks of the mountains. Note the following changes in the

The background colors are reduced to a cool blue-gray, leaving tones very pale. Textural detail is lost in a misty haze.

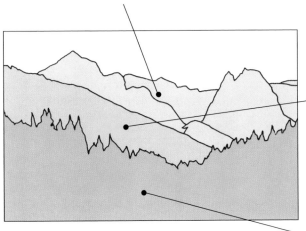

Middle-ground colors become cooler and less intense. Contrasts of texture and tone are less marked.

The foreground colors are warm and intense, with tonal values at full strength. Textural details are clearly defined.

landscape as it progresses from foreground to background.

Colors become cooler and less intense the closer they are to the horizon. Compare the bright, warm greens in the foreground to the misty blues of the distant mountains.

Tonal values become paler and weaker in the distance due to the intervening atmosphere. In *Alpspitze* the misty blue peaks in the distance are barely suggested, and this lends a touch of poetry to the picture, a sense of infinity that is always fascinating to the viewer.

Detail and contrast are sharpest and clearest in the foreground, becoming hazy and blurred in the distance.

In watercolor, the most effective way to achieve the effects of aerial perspective is to work from background to foreground. Begin with a "whisper," using pale tones and soft outlines at the horizon, and work up to a "shout" in the foreground, introducing progressively stronger tones and colors and greater textural detail.

ALPSPITZE by Ronald Jesty

Aerial Perspective

The laws of perspective apply to the sky just as they do to the land — yet so many perfectly good landscape paintings are ruined by a sky that looks like a limp curtain hanging at the back of the scene.

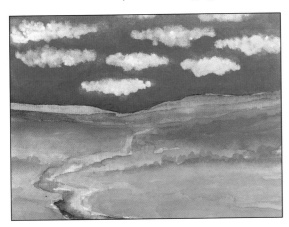

Lucy Willis (page 108) gives an exciting impression of the vastness of the sky. The way the picture is composed, with a very low horizon line, makes us feel involved in the scene, as if we were actually standing in the field looking up at the heaped clouds advancing toward us. Note also how the clouds overlap each other, creating an interesting diversity of shape and design.

In the painting above, for example, the sky appears curiously vertical. The clouds are too similar in size and shape, and they're too evenly spaced, destroying the illusion of the sky receding into the distance. In addition, the patches of blue sky are too uniform in tone and color, without any gradations to indicate atmospheric perspective.

Another mistake here is in placing the horizon line too high up, so that the land competes with the sky for attention. If the sky is to be the main feature, lower the horizon line so that the land becomes subordinate.

In contrast to the problem painting above, *Somerset Levels* by

LINEAR PERSPECTIVE

Clouds appear smaller, flatter, and closer together as they recede into the distance, often merging into a haze at the far horizon. Perspective can be heightened even further in the painting by making the nearest clouds much larger, taller, and more clearly defined than the others, as Lucy Willis has done.

ATMOSPHERIC PERSPECTIVE

In creating a sense of perspective in the sky, it helps to think of it as a vast dome stretched over the

landscape, rather than a mere backdrop to it. Creating this domelike impression means applying the laws of atmospheric perspective as well as linear perspective.

The sky directly overhead is clearer than at the horizon because we see it through less atmosphere. As we look into the distance, intervening particles of dust and water vapor in the air cast a thin veil over the landscape and sky, making them appear grayer and less distinct. Reproducing the effects of aerial perspective in any sky paintings will greatly increase the impression of depth and atmosphere. In *Somerset Levels*, the "white" clouds near the horizon are tinged with blue-gray, whereas those in the foreground are brighter and clearer. Accentuate the effect of atmospheric haze by blurring the edges of the furthest clouds wet-on-wet and reserving any crisp edges for those in the foreground.

Warm blues bring the foreground sky closer.

Clouds nearest to the viewer are large and strongly colored.

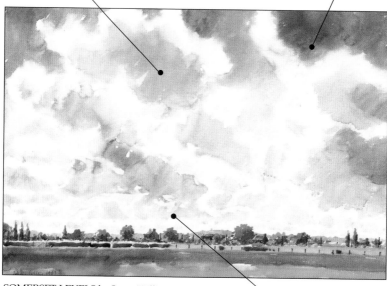

SOMERSET LEVELS by Lucy Willis

The clouds become smaller, flatter, and lighter in tone as they near the horizon. The horizon line is low, which places emphasis on the sky and increases the illusion of space.

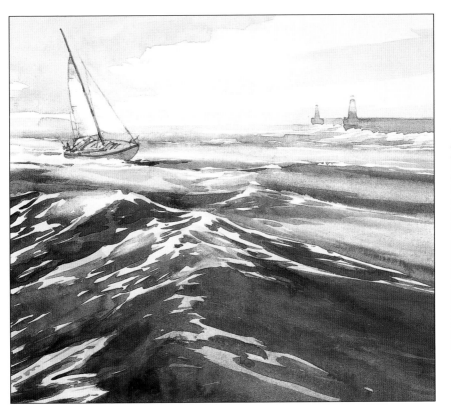

This painting gives a strong impression of space, created both by the use of paler colors toward the horizon and by the diminishing size of the waves and the brushmarks used to describe them.

Tone

This simply means the lightness or darkness of a color, and has nothing to do with the blueness or redness of the paint.

Tone is just as important as color in a painting, and many painters, particularly in the past, have been more interested in tone than in color. Paintings were traditionally built up in monochrome, with the colors put in last on top of a detailed tonal underpainting. It is an interesting fact that a black-and-white photograph of a painting in which the colors were painted quite differently from the colors of the subject but the tones kept true to life would look entirely normal.

The colors of the spectrum have varying tones because our eyes are more sensitive to some colors than others. Yellow is always light in tone because our eyes are most sensitive to it, while pure red and pure blue appear the darkest. Incidentally, in dim light our eyes are most sensitive to green and blue, while reds become very dark.

SELF-PORTRAIT BY WINDOW by Lucy Willis, oil, 15 x 12 in. Large dark areas contrast strongly with equally large light ones in bold geometric shapes—the rectangles of the window, the triangle of the neck, the circle of the face, and the crescent of the hair. The delicate, sinuous forms of the plant relieve the starkness of the picture and also help to relate the pattern on the facial features to the window, and hence to the rest of the painting.

TONAL KEY

As well as a color key, a painting has a tonal key, which can be described as high (light colors) or low (dark colors). It can also encompass a wide scale of tones from very dark to very light. The tonal key can be used to set the mood of a painting. A dark picture tends to be somber or serious, whereas a picture in a high key may be more lighthearted. This is by no means a hard-and-fast rule. One may expect a nighttime painting to be dark, but this is not necessarily the case. Very often a successful painting depicting a night scene may be in a high key. Conversely, a picture of a subject in broad daylight or even in bright sunlight may be painted in dark tones. As in the case with color, too many tones in one painting may cause confusion to the viewer, possibly making the picture appear disjointed and destroying its overall harmony.

MELANIE CONTRE JOUR by Ken Howard, oil, 9 x 7 in. This painting depends for its effect almost entirely on the pattern made by the distribution of lights and darks—color is minimal, verging on monochrome. Imagine how dull the picture would be if the chair were not there. Its pale seat contrasts with the shadow to the right, while the dark area beneath it is in counterpoint to the pale-colored floor. The bars of the chair connect the upper and lower halves of the picture and are echoed by the horizontals and verticals of the window frame. Turn the picture upside down so that it can be seen as an abstract arrangement.

Color

Most colors have been standardized and the same color names occur in different brands as well as other painting media. This makes it easier if the color in the artist's usual brand is not obtainable.

There are more than eighty colors, but only a fraction of these are needed to get started.

Each color has different physical properties, which need to be understood, as it will affect the way the colors are mixed and used. Some colors are very concentrated and only small amounts are needed, otherwise they overpower other colors on the palette. These strong colors tend to be the dyes like alizarin crimson and phthalocyanine blue. Others are granular, leaving grainy textures, but are less intense in hue.

Watercolors obey all the same color laws as other media, but there is one important difference in that watercolor is transparent. Instead of adding white to make a color paler, add more water, causing greater fluidity. The color of the paper, usually white but occasionally tinted, plays an intrinsic part because the colors laid on it are transparent glazes that allow the paper to show through. These two pages and those that follow, which explore some of watercolor's unique properties, will help you to understand and appreciate this attractive medium.

THE PRIMARY COLOR WHEEL

Red

Yellow

Blue

The Color Wheel

The color wheel is a useful device for seeing how different combinations of colors can be used together effectively.

Some color wheels show the pure colors based on those of the spectrum (the colors of light), but this one is a pigment wheel, which includes all the basic palette colors. Notice that the warm colors—the reds and yellows—are close together, with the cool blues and greens on the other side. The colors directly opposite one another (red and green, yellow and violet) are complementary colors. Both complementaries and warm and cool colors can be used to create different moods and effects in a painting.

Phthalocyanine blue

Purple

Ultramarine blue

Mauve

Cobalt blue

Alizarin crimson

Cerulean blue

Crimson lake

Viridian

Cadmium red

Phthalocyanine green

Raw sienna

Cadmium green

Yellow ocher

Emerald green

Cadmium yellow

Sap green

Lemon yellow

Color Temperatures

Some colors are described as "warm" and others as "cool," the former being the reds, oranges, and yellows and the latter being the blues, blue-grays, and blue-greens.

A painting with an overall blue color may give you a feeling of tranquility, while one in reds, oranges, and yellows may give an impression of warmth. The origin of these temperatures may be partly a matter of everyday associations — an overheated person goes red in the face, the hot sun is orange-red, blocks of ice have hints of blue, as do the shadows in a snow-covered landscape. But whatever its origins, color temperature is a useful tool in a painting, particularly to create a feeling of space and recession. Just as a line of distant hills appears as a cool blue-gray, the cool colors tend to recede while the warm ones push themselves into the foreground. However, like everything to do with color, this is relative. Although the blues are theoretically all cool, some are warmer than others and some reds cooler. For instance, Prussian blue is cooler than ultramarine, which has a hint of red in it, while alizarin crimson is cooler than cadmium red.

A successful painting usually has contrasting or interlocking areas of either warm and cool colors or of dark and light tones, or often both. A painting that lacks these contrasts, for example, one that is all pale and painted entirely in cool blues and grays, besides failing to catch the eye, will be off balance and unpleasant to look at. It is a good idea to try to counteract warm areas with cool and vice versa even if it's just by using a warm ground showing through paint that is otherwise mainly cool.

As we have seen, cool colors tend to recede, but in spite of this, the shape of areas tends to be more powerful than the color's temperature. The nearest feature in Hans Schwartz's *Market Collioure* (opposite) is a cool blue in the bottom right-hand corner. However, in the distance (at the extreme right) is a woman in a warm orange dress that tries its best to jump out at you but is continually pushed back into the distance again simply because we know that is where it belongs. Another interesting play between warm and cool is found in Tia Lambert's *Glass Comport* (page 116). Look also at *Val D'Entre Conque* on page 117.

COLOR BALANCE

The distribution of light and dark areas, warm and cool areas, and the pattern made up by its colors gives rise to the balance of a painting. A badly balanced painting is one that does not make a whole, that is, one that looks as if it needs a portion chopped off, or one that gives the impression that it is really part of a larger picture.

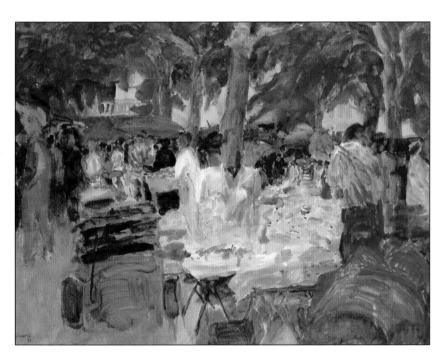

MARKET COLLIOURE by Hans Schwartz, oil

Here the artist has deliberately avoided harmony because he wanted to create the impression of a busy, bustling scene. The bright colors jump out at you, keeping the eye constantly moving over the picture surface. The effect is accentuated by the way the paint has been applied—rather thin, with bold, directional brushstrokes. But the disharmony is carefully controlled and the picture is held together by the way the dominant blues and greens have been repeated all over the surface.

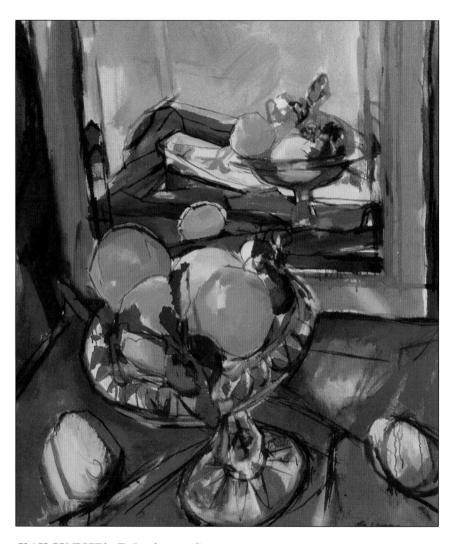

GLASS COMPORT by Tia Lambert, acrylic

The interplay of bright, warm reds and yellows with equally bright but cooler blues and greens creates a lively and vigorous, but far from restful, image. It is interesting to see how the warm colors advance and the cooler ones recede, even though the position of the objects in space tells us something different. For example, the red mirror frame jumps toward us even though it is actually behind the blue cloth in the foreground, while the yellow patch in the reflection, the furthest away from us, is one of the most dominant features in the composition.

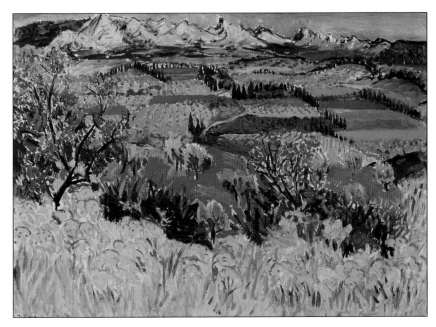

VAL D'ENTRE CONQUE by Frederick Gore, oil
One way to avoid muddying colors is to keep mixing to a minimum, but in inexperienced hands this can result in a garish and unharmonious picture. Here, extremely skillful use has been made of cadmium red, cadmium yellow, and ultramarine, largely unmixed and straight out of the tube, establishing an overall color key of red, yellow, and blue. Notice how the yellow flowers stand out against the blue and purple background.

STRAND ON THE GREEN
by William Bowyer, oil
This is largely a low-key painting, with most of the colors dark, almost black in places. The painting nevertheless has great brilliance and power, due not only to the colors themselves, but also to the method of paint application and the contrast of tones. The brightest part of the painting is the river, contrasting sharply with the dark shapes of the boats and the deep, rich blues beyond.

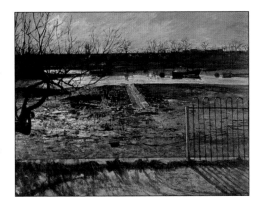

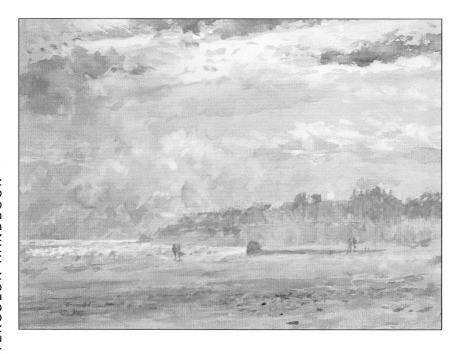

WHITLEY BAY LOOKING SOUTH by Jacqueline Rizvi, watercolor

This is a very high-key picture, eloquently capturing the luminous light of the sky and sea. Imagine a dark or bright color placed in the foreground — it would have completely destroyed the effect. The lightest touches are pure opaque white laid over the basic watercolor washes, and the darkest, the figures and other features on the beach, are nowhere near the darkest end of the tonal scale. The color range is also very subtle, with the muted blue at the top of the sky appearing quite brilliant in the context of the pale, warm grays with their hints of yellow and pink.

The Importance of Light

The scale and effects of color found in nature cannot be reproduced by the use of pigments on a flat surface; nor is it possible for the range of color to be produced with total realism.

This is because what we see when we look at colored objects is not the objects themselves but the color reflected from them. Our seeing, therefore, is dependent entirely on light and an artist is faced with a complicated process when putting brush to paper. Not only must he present a three-dimensional space on a two-dimensional plane, but his pigments and brushwork must imitate a wide and varied color range that in reality is reflected light. These limitations and difficulties are forced upon the artist; others are self-imposed. It is in dealing with forced and self-imposed limitations that the skill of the watercolorist lies. They are, comparatively speaking, so great and the process of adaptation so intricate that they present scope for the exercise of a wide range of choices, selection, taste, and the expression of personality. Here watercolor becomes an art and not a simple copying process.

HOW THE EYE SEES COLOR

The retina at the back of the eye is made up of rods and cones that are sensitive to light and color. The cones react to blue-violets, greens, and reds, the light primaries, and are dispersed on the retina in these three groups. They react strongly or slightly to colors seen and between them are able to mix up the entire range of colors. If you stare for any length of time at a red ball, the red-sensitive cones will overreact and become tired out; if you were to turn immediately to a white surface, which consists of red, green, and blue-violet, only the green and the blue-violet would work strongly. You would see, therefore, not just a white surface but also the afterimage mixture of a green-blue—or cyan—ball.

These are the light primaries: red, green, and blue-violet. Just as absence of light produces darkness, mixing light will result in a lighter color and mixing the three light primaries produces white.

Tone and Hue

Two ways in which color can be distinguished are in terms of tone and hue. Hue describes the color itself, while tone is the darkness or lightness of the color.

A whole range of tone can be present in a single-colored object and a good exercise would be to paint a single-colored object lit only from one side. This would produce a whole range of tones of one hue in the object, ranging from highlights to deep shadows. Tone is often very difficult to assess and many artists find themselves squinting. This has the advantage of reducing detail and giving a view of the object or landscape as a whole, thus allowing the judgment and assessment of tones to be made more easily.

In terms of landscape, most of the picture will be made up of a variety of greens. How can these greens be made more interesting as color? Are they warm, cool, brilliant, dull, acid? What evidence of other colors do they show? A red flag on a golf course will bring out the contrast of the greens more sharply. Experimentation in mixing up a variety of greens will show how wide the choice can be; by stretching blues and yellows to the furthest edge of the color spectrum and by making the greens as warm and cool as possible by adding more blue or red hues, it can be seen how exciting a range is obtainable.

A selection of seemingly white papers will show that white will vary from off-white to cream to gray-white. In the same way, the whites, when painting, should always be qualified and never used straight from the tube. Consider which color the white tends toward; pure white is rarely either seen or used except perhaps on the highlights of a shiny surface. In the same way a shadow or a changing surface is not necessarily merely a darker tone of the same color. The tone of the shadow may tend toward warm or cool gray, in some cases it may be purple, or for example, with a green object, it may be its complementary, red. These areas need to be examined very carefully and a true and selective eye is needed to record colors seen and not colors as they are thought to be seen. A good exercise for practicing this vision is to paint a still life entirely composed of white objects. The whole range of the palette will be used—not just white, black, and gray.

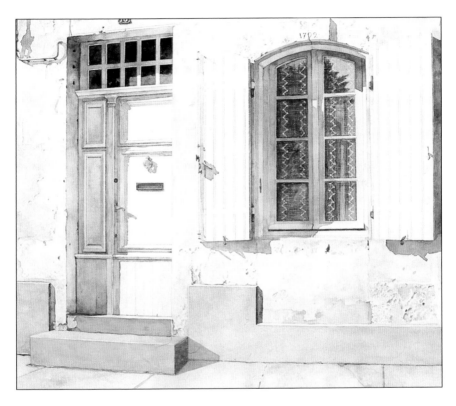

When dealing with a scene that is predominantly white, it is crucial to be aware of any small changes of tone and texture and odd flashes of color. These can be drawn out, even with a limited palette, to make sure that the surface of the painting is interesting and varied. The cool tone of the deep shadows contrasts with the warm yellow in the stonework and accentuates the brilliant white light. Pattern and texture in the wall and windows are used to break up the broad planes. A confident handling of perspective adds three-dimensional reality.

Color Mixing

The world of color can be beautiful but bewildering, especially for a beginner to painting. The artists' color charts available show that there are nearly one hundred colors to choose from.

All are wonderful and have a place, but if you are just starting out, you would be best advised to start with just a few. You can learn about color by experimenting with different dilutions and mixtures of colors.

Just as a composer arranges musical notes to produce a melodious sound, so the artist should arrange his colors to create a harmonious image. The problem is that inexperienced painters often use too many colors, and use them at full intensity, so the finished painting lacks subtlety and harmony.

One way to overcome this habit is to try painting with a limited palette of colors. Every schoolchild knows that there are three primary colors—red, yellow, and blue—and that all other colors can be mixed from these. Try it for yourself with alizarin crimson, Indian yellow, and Winsor blue. Mixing any two of these together creates the secondary colors—orange, green, and purple. If you mix all three primaries, you can produce a wide range of grays, browns, and other neutral colors.

Get to know the colors you can mix with the primaries, then you can begin to add to your range slowly and carefully. Buy only one more color at a time and experiment again until you have discovered all the mixes possible. Some other colors that you might find useful are French ultramarine, indigo, cerulean, viridian, and the earth colors—yellow ocher, raw sienna, burnt sienna, light red, and burnt umber.

When mixing colors, remember that they always look darker wet on the palette than they will on paper. They will also dry lighter. For this reason, it is always a good idea to do a test on paper first and leave the paint to dry to check the final color. Remember, too, that you should have two jars of water when mixing—one for clean water for mixing the colors, the other for rinsing your brush. If the brush or the mixing water are already tinted with another shade, this will distort the mixed color you are trying to achieve.

1 Make up washes of various pure colors in different pans in the palette. Then, in a clean pan, blend two of the colors to make a third.

2 French ultramarine mixed with alizarin crimson makes a rich purple. Test the color on some paper to check its tone and density.

3 Yellow ocher and alizarin crimson combined makes a fairly clean and bright orange.

4 Yellow ocher mixed with ultramarine makes a natural-looking brownish-green.

Primaries and Secondaries

*A little knowledge of basic color theory is essential for the aspiring artist,
and will help you learn to mix colors successfully.*

The three primary colors—red, yellow, and blue—are those colors that cannot be mixed from any other color. From these you can mix the three secondary colors (mixtures of two colors)—orange, green, and purple—then the three tertiaries (mixtures of three colors), and so on. In theory you can mix all colors from the primaries.

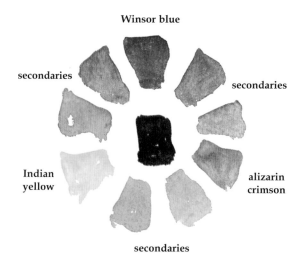

Winsor blue

secondaries

secondaries

Indian
yellow

alizarin
crimson

secondaries

Experiment by mixing together the different reds, blues, and yellows in your palette of colors and discover the myriad hues you can create. The three primaries above produce a range of bright secondary colors while those used on the opposite page create a more subtle, neutral range.

French ultramarine

secondaries

secondaries

raw sienna

burnt sienna

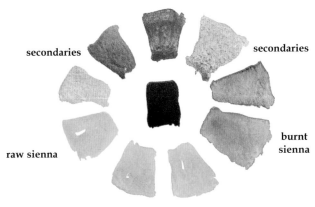

secondaries

Mixing two colors together to form gray: A wide range of grays is possible simply by varying the proportions of blue and red in the mix (and the proportion of paint to water).

French ultramarine

burnt sienna

125

Keeping Your Colors Fresh

Watercolor has a transparency that sets it apart from other painting media. Light passes through to the white paper and reflects back through the colors with a translucent quality that gives the medium its characteristic luminosity.

However, if colors are indiscriminately mixed on the palette, or if too many layers of color are built up on the paper, they may cancel each other and turn muddy and opaque.

When mixing colors, don't be tempted to blend them so thoroughly that they become flat and lifeless. Colors that are partially mixed appear much livelier. Try placing the individual colors on damp paper and blending them just slightly so that they blend together wet-on-wet. Alternatively, use the wet-on-dry method and apply thin, transparent washes one over the other, allowing each layer to dry before applying the next. Try to avoid mixing more than two colors together; three or more colors tend to cancel each other out and make mud.

The wetness or dryness of the brush is a critical factor in controlling the density and tone of your colors. To produce dark colors, for example, squeeze the excess water out of the brush with your fingers before picking up the color.

Always have plenty of clean water available, as dirty water will contaminate your colors. Two pots are best: one to wash dirty brushes, and one to pick up clean water for mixing colors. Always rinse your brush thoroughly before picking up a fresh color.

It is always a good idea to test a color on a piece of scrap paper before committing it to the painting. It is better to get the color right the first time and apply it with confidence than to apply three or four weak, muddy layers in trying to get the color you want. Finally, a word about paper: The unique white, light-reflecting surface of watercolor paper has a positive part to play in the freshness and luminosity of a painting. So don't be afraid to leave small areas of paper untouched, as they will breathe air and light into your paintings.

Lively mixtures can be created by allowing wet colors to mix on the paper instead of in the palette (see opposite page).

127

Two- and Three-Color Mixes

If two colors are mixed together in the palette, the resulting mixture will be an even, flat color with its properties already determined. But when two colors are mixed wet, on the paper surface, they blend more erratically, producing exciting effects. You can brush them together thoroughly or allow the water to blend them together. Both mixing methods are commonly integrated into one painting.

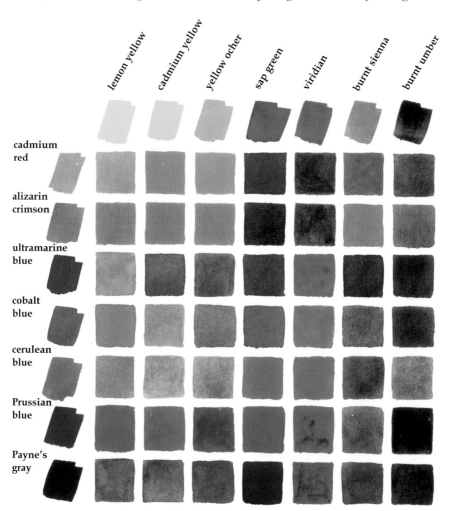

TWO-COLOR MIXES

At the outer edges of the chart opposite are the fourteen colors in the suggested starter palette, seven running down the left-hand side and seven along the top. The squares show the colors mixed together in equal proportions. Altering the proportions or adding more water can make further variations.

THREE-COLOR MIXES

When the three primary colors are mixed together, they have the effect of canceling each other out, producing a neutral gray. By using more of one color than another, you can give the neutral a more distinctive bias, for example a warm or cool gray or various shades of brownish gray. It is important to understand how to mix these neutral colors without producing muddy hues, as many subtle nuances of color are found in nature.

cadmium red · cadmium yellow · ultramarine blue

Left: The three warm primary colors are mixed together equally to produce a warm gray.

alizarin crimson · lemon yellow · Prussian blue

Right: The three cool primary colors are mixed together to produce a cool gray.

Overlaying Colors and Transparency

Because watercolor is transparent, you can mix colors on the paper surface by laying one over another. This can create a fresher, more vibrant effect than premixing in the palette. Overpainting colors has to be done carefully in one stroke to avoid disturbing the undercolor.

OVERLAYING TWO COLORS

cerulean blue **alizarin crimson**

violet **lemon yellow**

These examples show the overlaying of first two colors and then three—where all three circles meet. Subtle color mixes can be achieved that may have a bias to the more dominant color. The left-hand mixtures, for example, are dominated by the alizarin crimson.

OVERLAYING THREE COLORS

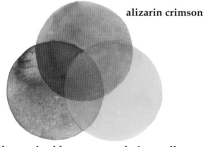

alizarin crimson

ultramarine blue **cadmium yellow**

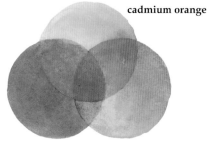

cadmium orange

viridian **alizarin crimson**

TRANSPARENCY

Some colors are less transparent than others. Here swatches of all the colors of the suggested palette have been painted over a bar of ultramarine to demonstrate this. Pigments are derived from different sources, either organic or inorganic, and they have different properties that affect their transparency. The sedimentary colors like burnt umber, for example, tend to be slightly opaque, while staining colors such as alizarin crimson are very transparent.

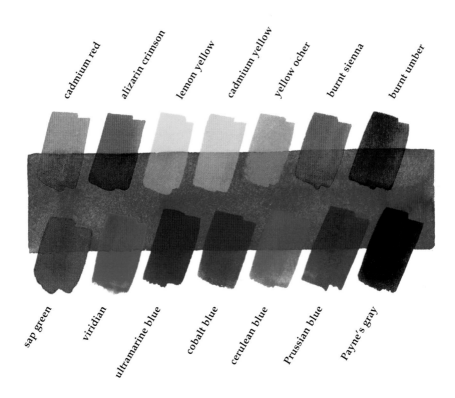

cadmium red · alizarin crimson · lemon yellow · cadmium yellow · yellow ocher · burnt sienna · burnt umber

sap green · viridian · ultramarine blue · cobalt blue · cerulean blue · Prussian blue · Payne's gray

Mixing without Muddying

No other medium can quite match up to the unique freshness and delicacy of watercolor — that is, if you know how to handle watercolor properly. For the beginner it can be very frustrating when colors that sparkle like jewels on the palette end up looking like mud on the paper.

So why do things go wrong? Usually muddy color is the result of muddy thinking. In an effort to make something look real, the inexperienced painter tends to fiddle about on the paper, pushing and prodding the paint and building up dense, chalky layers of color — as is the case in the still-life painting above.

Compare the rather gloomy aspect of the problem painting to Richard Akerman's *Floral Arrangements IV* (opposite), which is filled with radiant light, color, and excitement. Here the artist has built up his colors with thin, transparent glazes like delicate layers of tissue paper so that they retain their freshness and sparkle.

WHITE SPACE

For some reason, novice painters usually feel compelled to obliterate every inch of the paper with color, yet more often than not the light-reflecting surface of the paper itself has a positive part to play in the freshness and spontaneity of a watercolor painting. In *Floral Arrangements IV*, for example, areas of untouched paper breathe air and light into the painting and accentuate the delicacy of the colors.

DON'T OVERMIX

When mixing pigments together to create a particular color, don't be tempted to blend them so thoroughly that they become flat and lifeless. Colors partly mixed on the palette, so that the original

pigments are still apparent, have a much livelier color vibration. Try placing the pure, unmixed pigments on damp paper and blending them just slightly so that they fuse together wet-on-wet, as Richard Akerman has done in the background to the flowers.

KEEP IT CLEAN

When pure color is brushed onto white paper and allowed to settle undisturbed, the effect is clear and luminous. So don't prod, poke, dab, or scrub your colors once they are on the paper. Be sure of the color you want before applying it, then brush it on quickly and confidently. Watercolor painting is like playing golf; the fewer strokes you use, the better.

FLORAL ARRANGEMENTS IV by Richard Akerman

TIPS
FOR PROFESSIONAL RESULTS

• Layers of transparent color applied in thin glazes build up the form without looking heavy and overworked. Areas of bare paper reflect light and act as breathing spaces.

• Pools of color mixed wet-on-wet set up warm/cool vibrations.

• Mixing too many colors together on the palette creates dense, muddy color.

• Thin, transparent glazes allow light to reflect off the paper and up through the colors, giving them greater clarity and vibrance.

Mixing Skin Tones

Our skin is translucent and has a reflective surface, its color being affected not only by the blood vessels lying beneath it but also by the quality of the prevailing light and even the colors of nearby objects. In addition, of course, skin tone can vary widely from one person to another.

PORTRAIT OF GAYE by Paul Osborne

Faced with such a seemingly complex subject, some beginners resort to a vague approximation of what they believe to be the color of skin—usually a straightforward pink or brown.

In the painting above, the colors used are alizarin crimson, lemon yellow, and tiny amounts of ultramarine and raw sienna. But the artist doesn't mix his colors together on the palette, since this would make them go flat and lifeless. Instead, he partly mixes them on the paper with small brushstrokes, layer upon layer.

WARM AND COOL COLORS

The skin appears lighter and warmer in the prominent, light-struck areas and darker and cooler in the receding or shadowed parts. Because warm colors appear to advance and cool colors to recede, you can use warm/cool color contrasts to model the "hills and valleys" of the face, much as a sculptor pushes and pulls his block of clay. In *Portrait of Gaye*, notice the subtle hints of cool blue and violet on the shadow side of the nose and under the lower lip, and the warm yellows on the forehead and cheek.

LUMINOSITY

In a watercolor portrait, light reflecting off the white paper plays a vital role in creating an impression of the skin's natural luminosity, so

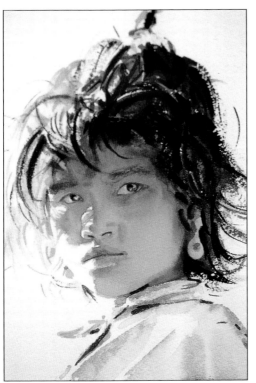

try to keep your colors as clear and fresh as possible. Following Paul Osborne's example, practice modeling the form of the face with small strokes of color, glazing thin layers over each other. Work on just-damp paper so that you can blend strokes wet-on-wet in the soft areas such as the cheeks.

THE GIRL ON THE ELEPHANT
by Rob Farley
It is notoriously difficult to paint the faces of children, because the skin is smooth and unlined. In this painting, however, the artist has not only captured the beauty of the face, but the spirit of this proud young girl.

TIPS
FOR PROFESSIONAL RESULTS

• "Lost" edges on the light-struck side of the face are more lifelike than a hard outline.

• Highlights can be gently blotted out with a tissue or a damp brush to give a natural sheen to the skin. Subtle modulations of color are achieved by partial mixing.

Mixing Greens for Landscapes

The range of greens that can be mixed is almost limitless. Varying the proportion of blue and yellow in each mixture increases the range still further.

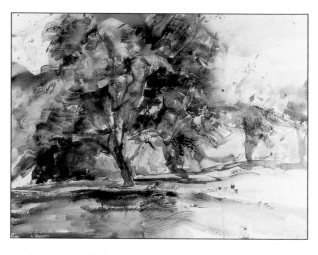

FORMAL GARDENS by Alex McKibbin The greens in this landscape are fresh and vibrant because the artist has built up his colors and tones with lively strokes of red, green, blue, and yellow. Note the reddish-mauve shades in the tree trunk and branches, made with loose strokes of purple madder alizarin, ultramarine blue, terre verte, and raw sienna. Red and green, being opposites on the color wheel, intensify each other when juxtaposed and here create an impression of warm sunlight.

We know that when two primary colors are mixed, the result is a secondary color. For example, blue and red, both primaries, make purple, but this does not tell us which blue and which red make the best purple for our needs. We have also seen that when complementary colors such as red and green are mixed, we get a muddy gray, so obviously we must avoid near-complementaries for our purple. Cobalt blue has a hint of green in it and when mixed with red it produces a grayish purple. To make a purer purple you'll need to choose a less-green blue, preferably one with a hint of purple. Ultramarine is the best bet. Next we must consider the red. A bright orange-red, such as cadmium scarlet, will muddy the blue, as orange and blue are complementaries, so this won't produce a satisfactory purple. The best red is the one nearest to purple: alizarin crimson is a good choice,

and magenta or rose even better. Some blue and red mixtures are initially very dark, but a small addition of white will bring out the character without destroying the hue.

The more transparent a paint is, the better it mixes because the pigment particles in the mixture do not get hidden behind each other so thoroughly. This is another reason why the opaque cadmium red is not as good for mixing compared to the transparent alizarin, magenta, or rose. Cobalt blue is also slightly less transparent than ultramarine, so it is not such a good mixer.

As seen below, blues and yellows mixed together give a wide range of rich and subtle greens. Tube greens, too, can be modified with other colors on your palette. Varying the proportions of the pigments used will give you even more combinations.

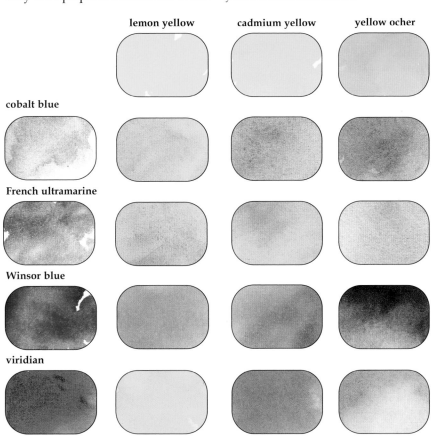

lemon yellow cadmium yellow yellow ocher

cobalt blue

French ultramarine

Winsor blue

viridian

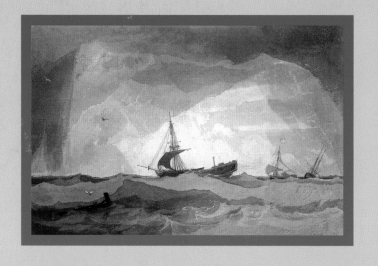

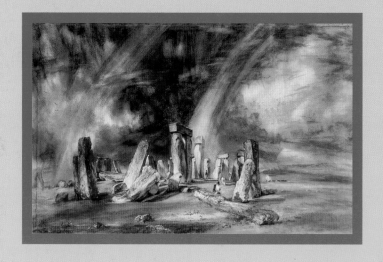

DEVELOPING A STYLE

Style in painting is often described as a distinctive manner of artistic expression. It cannot be consciously created or hurried along; it has to evolve naturally over time, just as one's handwriting does. As your drawing and painting skills develop, your own unique artistic style will begin to evolve and be recognizable to others. When that happens, you will feel you are at last beginning to achieve something.

The tool we use for painting will obviously have an influence on the style of our pictures. One artist may find that working with large brushes and rough paper in a loose, impressionistic manner suits his way of expressing himself. Another artist may prefer to work in a more detailed, precise manner using small brushes and smooth paper.

Artistic style, however, is not simply a matter of tools and technique, it is also about a particular way of seeing. An artist creates a painting not only by putting together a particular set of marks but also by choosing and composing the subject and then by manipulating both colors and tonal values so as to underline the message he wishes to convey. Of course, as a beginner your attention will focus initially on how to make a tree look like a tree or an apple like an apple. However, once you have mastered the basics of perspective, composition, and different painting techniques,

THE LEFT BANK, PARIS by Fritz M. Morrison

The energy of a Parisian street has been captured deftly and accurately here through a combination of loose washes and linear marks, and the rough-surfaced paper adds to the excitement by breaking up the colors. Happy accidents have occurred where wet washes have been applied over still slightly damp lines. A limited color range gives the painting unity, while small touches of bright color add a note of interest.

HARBOR DAWN by Karen Mathis
Precise drawing and clean, sharp-edged washes are a feature of this artist's work. Here is a marvelous example of diversity within unity; the echoing shapes of the boats make up a lively pattern of light and dark, while the limited color range lends unity to the whole.

you can begin to concentrate on interpreting—rather than merely copying—your subject matter. Your personal way of interpreting what you see is a vital aspect of painting and should not be underestimated.

An important step in developing your own style is to look at the work of artists whom you admire. Almost every great artist has been influenced by another artist before him, and you will inevitably be drawn to the work of a particular painter because it touches something deep inside you. The influence of that painter may unconsciously begin to appear

in your own work, but eventually something of yourself will come to the fore. It would be a good idea to study the work of the great English watercolorist J. M. W. Turner (1775–1851). Here was a man with a style all his own. He was not afraid of creating "accidents" on the paper and then manipulating them to create wonderful atmospheric effects. Many of his paintings were produced by flooding the paper with paint and then washing off the excess to leave delicate stains of color that he glazed one over the other, like sheets of tissue paper. Of course, there will be days when you

feel you are getting nowhere and you are dissatisfied with the work you are producing. All artists have these feelings from time to time, and it is always a good excuse to try something new. Experimentation is important; an artist should be moving forward constantly, developing new ideas, new ways of using paints and materials, new ways of thinking. Try tackling new subjects, changing your usual palette of colors, or using bigger brushes. Throw caution to the wind and slosh some big, wet, juicy washes onto wet paper. Try scraping into a wet wash or spattering paint on with an old toothbrush. Some experiments may mean wasting some paper, but it will be well worth it.

In the end, the best idea is to paint and paint and paint. As your skills develop, you will begin to paint with fluency and confidence, and your work will bear your own unique stamp.

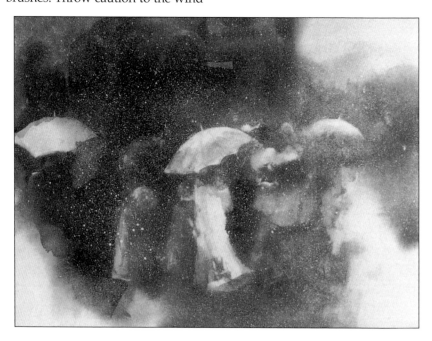

AFTER THE CONCERT by Berenyce Alpert Winick
The wet-on-wet technique is used to stunning effect here in capturing the atmosphere of a winter evening in the city. An almost monochromatic color scheme and minimal detail heighten the mood.

Two Artists, One Scene

It is intriguing to see how two artists, faced with the same subject, will interpret it in quite different ways.

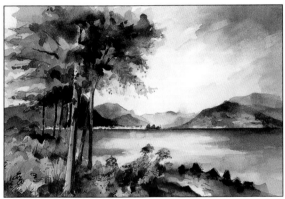

The first artist's interpretation of the subject has produced a wonderfully atmospheric painting, evoking the threatening mood of an approaching storm. This has been achieved through the use of a subtle color scheme and the skillful orchestration of dark tonal values.

Two artists were asked to produce a watercolor painting of the same scene of an Italian lake. The subject is identical in both and the compositions are very similar, yet the impression conveyed by each painting is quite different.

Both artists began by making thumbnail sketches and tonal studies to test out their compositional ideas and get to know the subject better. Their independent concepts began to evolve in the paintings, with the first artist using a direct, wet-on-dry method and the second artist using the wet-on-wet method. The contrast in atmosphere and mood between the two paintings is also quite distinct.

Although similar in composition to the first painting, the mood and atmosphere in the second painting are quite different. Light, fresh colors have been used to suggest the atmosphere of a bright, sunny day with a strong light coming from the left.

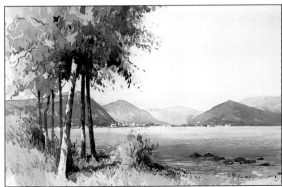

Studying the Watercolor of Cotman

Cotman was one of the greatest exponents of what is now known as the "classic" watercolor technique, that of building up a painting with a series of carefully controlled flat washes, overlaying colors wet-on-wet. He never used wet-on-dry methods – these were not current in his day – and until his later life he avoided using body color, preferring instead to exploit the transparent qualities of the medium.

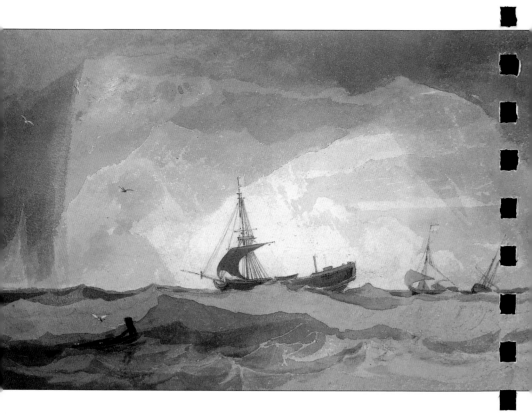

DISMASTED BRIG by John Sell Cotman

ABOUT THE ARTIST

John Sell Cotman (1782–1842) was the son of a merchant in Norwich, England, and became one of the leading figures in the Norwich Society of Artists, now known as the Norwich School, a group of landscape painters who exhibited regularly from 1805 to 1825. In 1798 the young Cotman left his hometown for London, where he worked as a copyist for Dr. Munro, a wealthy collector and amateur artist, who helped and encouraged many of the young watercolor painters of the day, including J. M. W. Turner and Thomas Girtin. The artistic climax of Cotman's career was in his early twenties, when he made a series of superb watercolors of Yorkshire landscapes, but although these are much admired today, they did not sell well, and Cotman was forced to accept various posts as drawing master to the daughters of the aristocracy. Throughout his life he was prone to acute bouts of depression and uncertainty about the merits of his own work, and in later life he tried to emulate the vivid coloring of younger artists whose work he admired, using a form of semiopaque watercolor made by mixing pigment and rice paste.

ABOUT THE PAINTING

Two things immediately strike us about this painting: the sureness of technique and the modernity of the treatment. The popular style in watercolor painting during the later nineteenth century was characterized by a high degree of detail achieved with many tiny brushstrokes; such paintings are much sought after by today's collectors. But Cotman was a "painters' painter," who took a much bolder and broader approach, editing out unwanted detail to express the essence of what he saw and making his varied and exciting brushwork an integral part of the composition, much as the impressionist and expressionist painters did over a hundred years later. This painting is a perfect example of "making less say more." As in many of Cotman's works, he used broad, bold, but carefully controlled washes to build up shapes of almost geometrical simplicity that give the painting a strong abstract quality, as well as being a powerful evocation of the subject matter. The composition is masterly, with the lovely, curving shape of the boat in semisilhouette against the bright area of sky and framed by the dark clouds. The angular shape of the large wave in the foreground balances that of the boat's sail and leads the eye up to the focal point.

POINTS TO WATCH

The golden rule when painting water in movement, whether waves, waterfalls, or the eddies and ripples of a stream, is not to overwork. This is especially important in watercolor painting, as it can lose its freshness so quickly. The trick is to simplify, as Cotman has done, looking for the main shapes and patterns, rather than trying to re-create every tiny wavelet or ripple that may make the painting look muddled and fussy. Take care also to relate the water to the sky so that they hang together in terms of color. Water always reflects the sky color in places but often has color of its own, caused by peat, suspended vegetation, or algae in the case of the sea.

OVERLAID WASHES

This area of sky (right) was done in several stages. Working on cream paper, two blue-gray washes were laid over one another for the lighter area of cloud on the right, leaving small lines and specks of the paper color showing. When these washes were dry, a darker one was laid over the area on the left and then a final dark wash was made, the color put on with a large, fully loaded brush and dragged down the paper to suggest a squall of rain. The seagulls were reserved as the paper color, a task that demanded considerable skill; today, most artists would use masking fluid.

USING THE PAPER COLOR

In the bright central area, the paper color comes into its own and has been left largely uncovered, save for a few light brushmarks of pale blue applied fairly dry so that the color has caught only on the top grain. This gives a slightly mottled effect that captures the softness of the cloud and contrasts with the flatter washes used for the patch of clear sky on the right and the gray clouds above.

PAINTING WAVES

Strong shapes, deep tones, and positive definition were needed in this foreground area to provide a balance for the focal point of the boat. A light gray-green wash was laid over the whole sea area and then the main triangular shape of the wave was established with a flat midtone wash, followed by a slightly darker one. In the immediate foreground, shaped brushmarks were laid side by side and over one another, with the tops of wavelets suggested by the little lines of the original pale wash left uncovered.

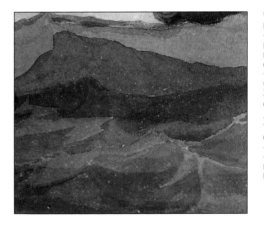

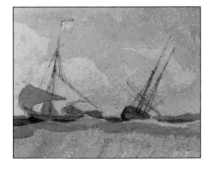

For a painting like this, working wet-on-dry with the highlights reserved, preplanning is essential, and the artist made a careful outline drawing of the boats; you can still see the pencil marks around the edges of the sails. The rigging of the boat was "drawn" in paint over the sky in the final stages, probably using the type of small, thin, long-haired brush now known as a rigger.

Studying the Watercolor of Constable

By Constable's time, watercolor had begun to be treated seriously as a medium, but had not yet acquired either the full body of techniques that we can list today or the prejudices and lists of dos and don'ts that sprang up in the early twentieth century. Artists felt free to experiment, finding their own way of working instead of following a prescribed set of rules, and Constable worked very much as he would in an oil painting, exploiting brushwork rather than laying flat washes, and using stiff brushes for the sky instead of the usual watercolor brushes. Although Constable produced some very fine watercolors, he did not use the medium regularly and we cannot be sure of his precise techniques.

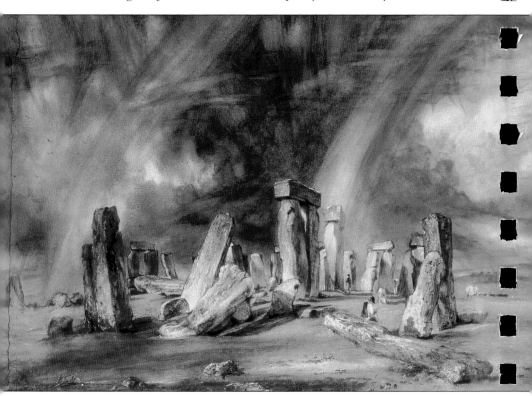

STONEHENGE by John Constable, 1836–7

ABOUT THE ARTIST

John Constable (1776–1837) was the son of a wealthy mill owner in Suffolk, England, and began to paint the landscape around his home in his youth, though he had reached his early twenties when he decided to make a career as an artist. He was unusual for his time in that he never left his native country. His contemporaries traveled widely in search of dramatic landscapes, but Constable found his subjects close to home and wanted no others.

He was never fully accepted by the art establishment and was only elected as a full member of the Royal Academy in the decade before his death, but is now seen as one of the greatest of landscape painters. He brought a new realism to the genre, turning away from the earlier conventions of highly idealized landscapes. These artists, he said, "were always running after pictures and seeking the truth at secondhand," while his concern was to convey firsthand experience of weather, the effects of changing light, and the infinite variety of nature. "No two days are alike, nor even two hours; neither were there ever two leaves of a tree alike since the creation of the world." He was especially fascinated by skies and made countless sketches of cloud formations that he later used for reference in his studio. Today Constable's oil and watercolor sketches, which look forward to the impressionist movement over a century later, are more admired than his large exhibition works.

ABOUT THE PAINTING

This painting provides the perfect example of how to create drama on a small scale—it is only slightly larger than the reproduction shown here, yet its impact is such that we can imagine it occupying a whole wall in a picture gallery. Constable learned much from studying the old masters, and in all his compositions he exploited the chiaroscuro (bright against dark) effects beloved of painters such as Caravaggio and Rembrandt. It is mainly this, combined with the energetic and inventive brushwork, that makes the painting so exciting; but he has also used another kind of contrast, that between the solid forms of the stones and the evanescent quality of the sky. The stones and foreground are built up very strongly, serving as an anchor for the restless movement above.

The painting dates from the last years of Constable's life, and it is not known for certain whether it was done on the spot; it may have been partly worked in the studio from a smaller sketch. Constable sketched extensively out of doors and in his attempts to render the English landscape truthfully, he often

SMALL HIGHLIGHTS

These small flecks of creamy white, representing points of light, are typical of Constable's work. In his oil paintings, these were laid over other colors with thick, white paint, but here he has reserved the tiny highlights by using the texture of the paper, dragging rather dry paint over the surface so that it has only partially covered the grain. Some highlight areas were then reinforced by scratching away dry paint; you can see this especially clearly on the foreground grasses. An alternative method would be to paint on masking fluid and scruff it slightly with a finger before laying on the color.

abandoned traditional methods, as in the rapid brushwork of the sky here, and his works were criticized by his contemporaries for their lack of smooth finish. But he had his admirers, among them the Swiss-born painter Henry Fuseli, who is reported as saying, "I like the landscape of Constable . . . but he makes me call for my greatcoat and umbrella."

POINTS TO WATCH

Stormy skies and dramatic light effects make such an exciting subject that there is a danger of losing sight of the overall construction of the picture, especially if you are working on the spot and are in a rush to capture the effects before they change.

Constable, ever mindful of composition, has planned his landscape with care, dividing the picture space in the classic way, with foreground leading into middle ground and then into the distance.

DIRECTIONAL BRUSHWORK

This detail above shows the way in which Constable has adapted his oil-painting methods to the very different medium of watercolor. He has used a stiff brush, following the direction of the sky's movement, and laying colors over one another wet-on-dry so that the brushmarks remain distinct. He may have thickened the paint with a medium such as gum arabic, which is useful for such effects. Paint can also be thickened with soap.

CREATING TEXTURE

The rough texture of the ancient stones is an important feature, and here the texture of the paper has helped to convey it. The paper has a rougher, less regular surface than today's popular Not surface, machine-made paper, so that the paint catches only on the top grain, producing a mottled effect. It is worth trying out a Rough paper for such effects, or they can be produced by the wax-resist method, a popular technique in the modern watercolor painter's repertoire.

SUBJECT

*Once you have mastered the basic techniques of
watercolor, you can fully exploit its versatility and
vitality. Watercolor can be delicate and translucent
or strong and stirring; it can depict rich detail
or subtle tonal effects. The only limits are
those of your own imagination!
Still life offers the luxury of a subject that
doesn't move and that can easily be arranged into a
pleasing composition. People and animals present
particular challenges as living subjects, although they
can be particularly satisfying to paint. Landscape is also
an excellent discipline; as watercolor is a light and
portable medium, it is ideally suited to outdoor work.*

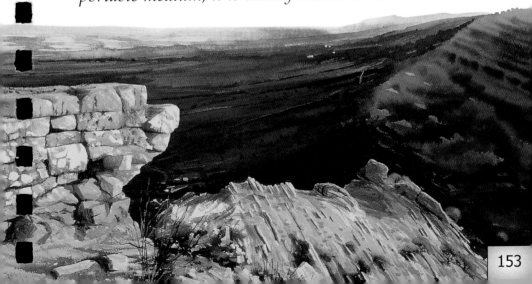

Still Life

There was a time when drawing objects such as plaster casts, bottles, and bowls of fruit was regarded as the first step in the training of art students.

Only after a year or two spent perfecting their drawing technique would they be allowed to move on to using actual paint, while the really "difficult" subjects such as the human figure were reserved for the final year. This now seems an arid approach, almost designed to stifle any personal ideas and talent, but like many of the teaching methods of the past it contained a grain or two of sense—drawing and painting "captive" subjects is undeniably a valuable exercise in learning to understand form and manipulate paint. But painting still life can be much more than this. It is enormously enjoyable and presents almost unlimited possibilities for experimenting with shapes, colors, and composition, as well as technique.

The great beauty of still life lies in its controllability. You, as artist, are entirely in charge. You decide which objects you want to paint, arrange a setup that shows them off to advantage, and orchestrate the color scheme, lighting, and background.

Best of all, particularly for those who dislike being rushed, you can take more or less as long as you like over the painting. If you choose fruit and vegetables, they will, of course, shrivel or rot in time, but at least they will not move. This degree of choice allows you to express your own ideas in an individual manner, whereas in a portrait or landscape painting, you are more tied to a specific subject.

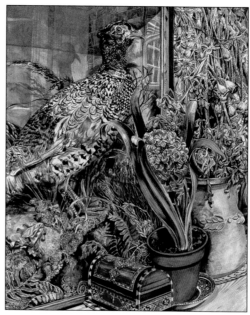

STILL LIFE WITH PHEASANT AND HYACINTH
by Cherryl Fountain

FINDING A THEME

Most still life paintings have a theme. The kitchen provides suitable subjects in the way of crockery, utensils, or food; flowers or fruit provide scope for including small insects, wasps, or butterflies; bloodthirsty scenes of flayed oxen and butchers' carcasses are traditional still life material. Outside the more usual range of subjects, groups may present interesting color themes and juxtapositions of shapes and tones so that bizarre and unlikely items can be incorporated into successful still lifes.

A color theme is often the only link between a group of objects and the subtle variation of color within a very limited range can be both challenging and instructive. Animate and inanimate objects can be combined, with textures ranging from that of a sponge, for instance, to the dimpled skin of an orange, to the hard surface of shiny plastic, with only a color theme to supply the link in your composition.

1 Draw the outline of the steam engine, laying in the background washes of the trees and grass in cobalt blue and lemon yellow and touching in the yellow highlights on the engine.

2 Block in the midtones on the engine, using a mixture of French blue and raw umber, and light red to simulate rust. Wipe off areas to give lighter tones where desired.

3 Lay a darker wash over the engine, observing carefully the areas of highlight and shadow and using viridian, light red, French blue, and other dark tones to depict the subtle differences of browns.

4 Increase the depth of color in the background and foreground, working clouds, and areas of shadow.

TRACTION ENGINE
The limited palette used in the painting of this traction engine has helped to maintain a color harmony, yet a sufficient variety of colors has been used to enable the subtle differences in browns to be depicted. Wet washes have been allowed to dry with hard edges and have been overlaid to strengthen some areas and build up the forms of the engine.

standing in line, and so the group looks staid and static.

Another common mistake in the design of a still life is to leave too much space around the group. In this painting the objects are lost in a sea of monotonous background.

SETTING UP A GROUP

When faced with a group of objects for a still life painting, it's all too easy to choose and arrange them in a way that's haphazard and lacking in thought. The problem is that we tend to choose objects that take our fancy, without stopping to think whether the objects will work together as a group in terms of size, shape, color, and so on. In the still life above, for example, we have a wine bottle (the obligatory wine bottle!), a vase of flowers, a hat, and a dishtowel; two tall, thin shapes and two flat shapes, with nothing to link them together. The student, in common with many beginners, seems averse to the idea of overlapping objects; everything is

It's important to compose a still life so that each individual element contributes to the total design. There is a pleasing harmony and rhythm to the objects in Pamela Kay's painting, *Tureen of Mandarins with Orange Preserves* (page 158). Somehow, everything just sits right. The group forms a roughly oval shape within the borders of the picture, and everything in the group is organized so as to carry the eye of the viewer on a visual tour of the painting. Another nice touch is that each of the objects in the group shares a common theme — they are all kitchen objects and all are connected with the process of making preserves.

UNIFY THE SUBJECT

When you have a group of objects of different size, shape, and color, it is vital that they relate to one another and that the spaces between the objects also make interesting shapes. Play around with the arrangement of the objects before starting to paint and make rough sketches so you can see how the overall shape of the group will look on the paper. Look for points where objects can overlap, because this ties the objects together and creates interesting shape relationships.

REPETITION AND VARIATION

Try to repeat the shapes and colors within the group because this sets up visual rhythms that the viewer will respond to. Repeating shapes and forms can also unite and integrate the objects in your still life and prevent them from appearing too scattered. A word of caution, however: Beware of making these repetitions too regular, as this can lead to monotony. Introduce subtle variations of size, shape, or tone to add spice to the design. In Pamela Kay's painting the rounded shapes of the bowls, the oranges, and the preserves jar create intriguing visual echoes, yet none is exactly like the other. The same applies with the geometric shapes of the other objects. The colors, too, are nicely tied together, with variations on the blue/orange theme repeated throughout.

TUREEN OF MANDARINS WITH ORANGE PRESERVES by Pamela Kay

Fruit and Vegetables

Fruit and vegetables are always popular in still life arrangements. Not only do they have fascinating surface textures, but also their colors and shapes can be all-important in lending balance to the composition.

STILL LIFE WITH APPLES by Shirley Felts

As with flowers, fruits and vegetables look best when they are not forced into a rigid arrangement. Try to place them so that they appear to have just spilled out of a basket, and introduce variety by including pieces of cut fruit or vegetables such as onions and cabbages, chopped in half to reveal their inner patterns.

Beginners often make the mistake of rendering shadows by adding black to make a darker version of the local color of the object. In fact, colors become cooler as they turn into shadow and contain elements of their complementary color. For example, the shadow side of an orange will contain a hint of its complementary color, blue. In addition, shadows often contain subtle nuances of reflected light picked up from nearby objects.

Highlights, too, are worth close scrutiny. Even the brightest highlight on a shiny apple is rarely pure white. If the prevailing light is

For example, a painting that is light in tone overall can be given just the right amount of contrast by adding a bunch of black grapes; on the other hand, dramatic chiaroscuro effects can be achieved with pale, luminous green grapes or pieces of lemon in a dark painting.

159

cool, the highlight might contain a hint of blue; if the light is warm, the highlight may have a faint tinge of yellow. By paying attention to such details, you will give your paintings a feeling of light and form.

APPLES

Here is another simple watercolor study in which the artist uses transparent washes and glazes to model the form of the apples and bring out their luscious texture.

1 With a mixture of sap green and cadmium yellow, the artist blocks in the overall shapes of the apples on damp paper. This is allowed to dry before moving on to the next stage.

2 Working wet-on-wet, the artist brushes in mixtures of sap green and brown madder alizarin to build up form and color, leaving small areas of the pale underwash to create highlights.

3 The reds and greens are strengthened further with transparent glazes, and the artist follows the contours of the apples with his brushstrokes. In places the color dries with a hard edge. This gives the impression of the crisply modeled form of an apple, which differs from the smooth roundness of an orange or a peach. When the apples are complete, the stalks are painted with raw sienna and a hint of ultramarine.

Finally, the cast shadows of the apples are painted with washes and glazes of indigo and purple madder alizarin. A clean, damp brush is used to soften the shadows so that they don't look too harsh. This also gives the impression that the apples are sitting on a shiny surface.

Backgrounds

One of the most common mistakes in still life painting is to treat the background as unimportant.

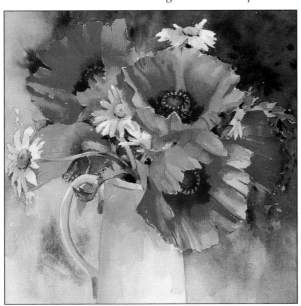

POPPIES by Adalene Fletcher

• SUBJECT •

It is easy to feel that only the objects really matter and that the spaces behind and between them are areas that just need to be filled in somehow. All the elements in a painting should work together, however, and backgrounds, although they may play a secondary role, require as much consideration as the placing of the objects.

The kind of background you choose for an arranged group will depend entirely on the kind of picture you plan. A plain or off-white wall could provide a good foil for a group of elegantly shaped objects, such as glass bottles or tall vases, because the dominant theme in this case would be shape rather than color. A group you have chosen because it allows you to exploit color and pattern would be better served by a bright background, perhaps with some pattern itself.

The most important thing to remember is that the background color or colors must be in tune with the overall color key of the painting. You can stress the relationship of the foreground to background when you begin to paint, tying the two areas of the picture together by repeating colors from one to another. For example, if your group has a predominance of browns and blues, try to introduce one of these colors into the background also. It is usually better in any case not to paint it completely flat.

Using Shapes

The freshness of watercolor depends upon the gradual building up from light to dark and any attempt to create highlights or pale tones in the final stages of the painting will alter the entire character of the medium.

Accuracy is thus all-important in the initial structuring of the composition. White shapes must be precise and clean, created "negatively" by careful drawing of surrounding color areas.

A light pencil sketch will help to establish the correct proportions, but complex shapes are outlined directly with a fine sable brush. Block in solid colors quickly or a hard line will appear around the edges of the shapes. Use large brushes to work into the foreground and background and lightly spatter paint dripped from the end of a large brush to create a mottled texture.

A limited range of color was used, mixing in black to create dark tones and varying grays with small touches of red and blue. Dry the painting frequently so that colors remain separate and the full range of tone and texture emerges through overlaid washes.

1 Draw the basic shapes of the objects in outline with a pencil. Mix a very thin wash of Payne's gray and block in the whole of the background.

2 Paint in the local colors of the objects, building up the paint in thin layers and leaving white space to show highlights and small details. Keep each color separate.

3 Mix a light brown from red and black and work over the red, showing folds and creases in the fabric and dark shadows. Lay a wash of brown across the foreground.

4 Work up shadows in the blue in the same way, using a mixture of blue and black. Move over the whole painting, putting in dark tones.

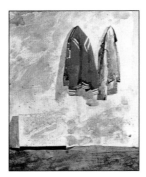

5 Strengthen all the colors, breaking up the shapes into small tonal areas. Bring out textural details by overlaying washes and spattering the paint lightly.

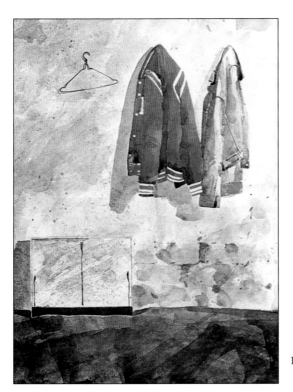

6 Intensify the dark brown in the foreground and use the same brown to indicate shadow on the wall behind. Vary the strength of the color.

Finished picture

Plants and Flowers

Flowers, with their rich and varied array of glowing colors, their intricate forms and delicate structures, are an irresistible subject for painters.

What is more, unlike the human and animal world, they do remain still for long enough to be painted. There are many different pictorial approaches to this branch of painting, all eminently suited to the medium of watercolor. Flowers can be painted in their natural habitats or indoors as still life arrangements, they can be treated singly or in mixed groups, and they can be painted in fine detail or broadly and impressionistically.

FLOWER PAINTING IN HISTORY

Today flower paintings are hugely popular and avidly collected. Good flower painters can command high prices for their work. This is a relatively recent trend in terms of art history, however. In the Medieval and Renaissance periods, when scientists were busily cataloging herbs and plants, the main reason for drawing and painting them was to convey information, and a host of illustrated books, called herbals, began to appear, explaining the medicinal properties of various plants and flowers. Many of the drawings were crude and inaccurate, but there were notable exceptions where the illustrators seemed to have worked from life, and these were the forerunners in a continuing and still flourishing tradition of botanical illustration.

The concept of painting flowers for their own sake owes more to the Flemish and Dutch still life schools than any other. The Netherlands artists had always been more interested in realism and the accurate rendering of everyday subjects than their Italian and French counterparts, and throughout the sixteenth, seventeenth, and eighteenth centuries they vied with one another to produce ever more elaborate flower pieces, with every petal described in minute detail. Artists have been painting flowers ever since, and although critics in France regarded flower pieces and still life as inferior art forms, even there they had become respectable by the mid-nineteenth century.

WORKING METHODS

Because flowers are so intricate and complex, there is always a temptation, whether you are painting them indoors or in the garden, to describe every single petal, bud, and leaf in minute detail.

In some cases there is nothing wrong with this (for anyone intending to make botanical studies it is the only possible approach), but too much detail in an arranged flower piece or an outdoor painting can look unnatural and static, and there is also the ever-present danger of overworking the paint and losing the clarity of the colors.

Before you start a painting, make some hard decisions about which particular qualities you are most interested in. If you are inspired by the glowing mixture of colors in a summer flower bed, treat the subject broadly, perhaps starting by working wet-on-wet, adding crisper definition in places so that you have a combination of hard and soft edges.

Always remember that flowers are living things, fragile and delicate, so don't kill them off in your painting—try to suit the medium to the subject. You can make a fairly detailed study while still retaining a sense of freedom and movement by using the line-and-wash technique, combining drawn lines (pen or pencil) with fluid washes. Never allow the line to dominate the color, however, because if you get carried away and start to outline every petal, you will destroy the effect. Masking fluid can be helpful if you want to be able to work freely around small highlights, and attractive effects can be created by the wax resist method.

Finally, even a badly overworked watercolor can often be saved by turning it into a mixed-media painting, so before committing hours of work to the wastebasket, consider using pastel, acrylic, or opaque gouache on top of the watercolor.

PANSIES by David Hutton

Making Still Lifes More Interesting

All too often, compositional decisions are made without sufficient thought and without exploring all the creative possibilities. This applies particularly when the subject is a simple one like a vase of flowers.

The inexperienced artist will often plump for the conventional approach and place the subject squarely in the center of the paper, surrounded by a plain background. While there's nothing intrinsically wrong with this setup, it doesn't always make for an interesting picture because it's too safe.

Floral still lifes offer you exciting opportunities for creating dynamic compositions. Don't limit yourself to approaches that are safe and comfortable. Experiment with unusual viewpoints, try out different backgrounds, explore the potential of color interactions. It is the uniqueness of your point of view that will make people take notice of your pictures.

Frank Nofer's *Rhodies* (opposite) has immediate visual impact. Note, for example, how the pale, delicate colors of the blooms are contrasted against a dark background—a simple, effective device, yet one that many beginners would not think of using. Note also how the artist has included not just one vase of flowers but two, and how they are cleverly linked by the single,

fallen bloom lying on the table. Remember, there's no reason why a floral still life has to consist of a single vase of flowers.

BE FLEXIBLE

When planning a floral still life, make it a rule never to let your first compositional decision be your last. Try to see beyond mere things—a vase of flowers resting on a table, or whatever—look at your subject as a series of shapes, colors, and patterns that must link together harmoniously. These shapes, colors, and patterns are also the "words" with which you will speak to the viewer, so choose and arrange them carefully.

USING A VIEWFINDER

To help you visualize the different compositional options, examine your setup through a cardboard viewfinder. First frame the overall composition. Does it look boring? Try moving in closer on one area. You may find that taking a small section from the subject will result in a more interesting composition.

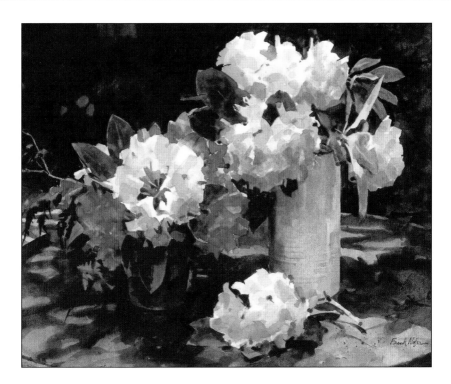

Above: RHODIES
by Frank Nofer

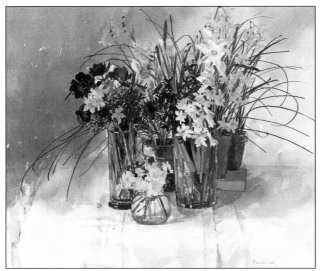

Left: HYACINTHS
AND PRIMROSES
by Pamela Kay
Too often, still lifes
appear static and
contrived, so it's
refreshing to see a
grouping like this
one, which has an
easy naturalness
about it.

CYCLAMEN STEP-BY-STEP

1 Make a careful drawing, then start putting in the color of the flowers. This has to be kept very pure, so use clean water. The negative and positive shapes of the flowers and the intervals between them are the main source of interest.

2 Start to work in the shapes of the leaves. At this stage do not worry too much about keeping inside your pencil lines; work the mid to light tones, using emerald green and Payne's gray cut with terra cotta and plenty of water.

3 Lay the first wash over the pot, again using plenty of water and moving colors around on the paper.

4 Work back a little into the greens, and into the pinks, using cadmium red medium and bright purple lake. Keep your water clean and make the shapes as interesting as possible.

5 Barely color the dish in which the pot stands. For the cloth, aim for a general sense of perspective rather than perfect regularity; it is helpful to draw a grid—checks become smaller, closer together, and lighter as they recede.

CYCLAMEN
This is a complex work demanding an initial organization of shape and space before color and tone can be added. Accurate drawing is all important and it is a good idea to take a second look after a break to check the initial marks you made on the page; if your initial drawing has been correct it will make it easier to relate shapes to each other as these become more complex. In this watercolor, the tablecloth was put in as an afterthought,

providing added color and interest and altering the character of the work.

Natural Habitat

One alternative often overlooked by painters is the possibility of painting a still life outdoors rather than in the studio. This is much more likely to be an appealing prospect in the summer rather than in the winter.

You may decide to make sketches and color notes rather than to produce a more finished painting, but either way it will certainly be both pleasant and instructive to paint outdoors in a natural environment.

• WATERCOLOR HANDBOOK •

FOREST AND FERNS, VERMONT
This woodland scene with fern fronds has been handled with a brush loaded with a delicate wash rather than by putting in a great deal of detail with dry paint. The intricate pattern of the ferns has, however, been achieved, created out of negative shapes by allowing the dark background to jut into the yellow of the fronds. The tree trunks give some structural balance to the work, acting as a background to the latticework of the ferns and providing a solid middle ground for the distant trees and leaves. The color of the trunks is built up with a series of washes, starting with a light yellow ocher, adding a slightly blue tinge, and working through Payne's gray and indigo to burnt umber.

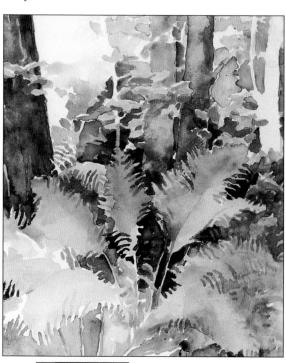

Left: The color is put on with a lot of water and allowed to move around and blend; where necessary, pick up excess color with a piece of tissue or cotton swab.

Choosing Colors

The pigments that flowers produce are among the most brilliant colors found in nature and even synthetic paints cannot match some of these. Once you have started to paint flowers you will soon find that your starter palette is too limited and you will want to try some of the other colors available. Since the manufacturers' names for their paints vary somewhat, it is best to ask in your art store for the types of color you want.

Sometimes you will be caught unawares during the course of a painting and will be forced to use the colors you already have. Fortunately, there are various illusory devices available to the artist to make colors stand out and sometimes appear brighter than they really are. We saw in the previous chapter how the eye responds to color relationships rather than absolute color, so it is quite possible to heighten the effect of a painted flower by contrasting it with its immediate surroundings. A neutral gray background will draw the viewer's attention to the colors of the flowers, and if the background is dark, the apparent tone of the flowers will be raised, the contrast

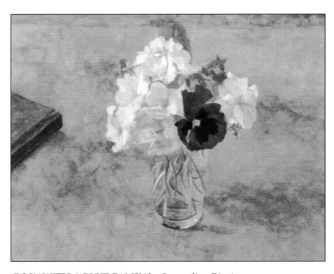

POSY WITH A BLUE PANSY by Jacqueline Rizvi
Very little, if any, pure white has been used here, most of the white petals having been painted in pinkish, yellowish, and bluish grays. Some of these are actually lighter than the lightest parts of the blue pansy. The stalks in the glass have been beautifully observed, their shapes accurately drawn, and their shadows and highlights carefully described, so we are fully aware of the water in the glass even though it cannot be seen directly.

making them seem brighter than if the background were light. The cooler colors—the blues, grays, and blue-greens—tend to recede when contrasted with warmer ones like red, orange, and yellow, so if a red flower is placed in surroundings of a cool color, the flower will make its presence felt by dominating that area of the picture. When complementary colors are placed side by side, they set up a dazzling effect where they meet, and the warmer or paler one of the pair will appear much more brilliant.

Try to keep the colors fresh by not overmixing, particularly in watercolor. To achieve greater luminosity for painting delicate petals in watercolor, the more transparent the paint the better, as the white paper can reflect through it. Instead of using the more opaque cadmium colors, those such as permanent yellow, permanent red, or vermilion may be a better choice (though vermilion is very expensive). In watercolor, ultramarine and cerulean are less transparent than cobalt or phthalo blue. Cerulean is quite surprisingly opaque and needs to be handled with some caution. Some of these effects can be found in the accompanying illustrations.

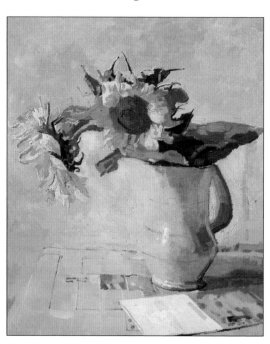

SUNFLOWERS by John Ward
The bright yellow of the flowers is highly illusory. If you look closely you can see that very little yellow has been used. Most of the petals are in warm greens, ochers, and reds, and by reserving the pure color for the highlights, the artist has not only given the flowers depth and form but also made them appear brighter. The cool blue-gray background enhances this effect, forcing the flowers forward. Notice also how although the tones of the tabletop and jug are very similar to those of the background, they are much warmer and thus read as being on the same plane as the flowers.

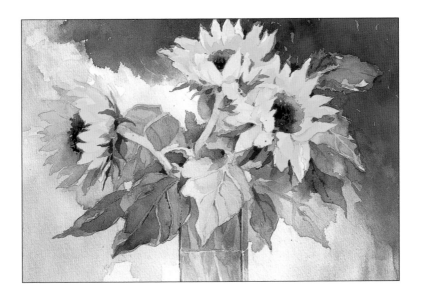

SUNFLOWERS by Adalene Fletcher

Above: The final touches of dark, cool shadow colors may now be applied. Mix varying shades of cool greens and violets and apply as shown using the tip of the brush. Throughout the painting, each layer of wet paint should have been allowed to dry completely before moving on to the next. If you are working indoors, a hair dryer can be used to speed up the drying time. The finished painting has a lively quality because the artist has exploited the contrast between the bright, warm flowers and the cool, dark background.

GERANIUMS AND CHECKED CLOTH by Nicola Gregory

Right: The subject of pattern in painting is worth exploring further. Try to create simple, balanced compositions and keep to a limited palette of colors, as in this painting, so as to produce a unified image.

Skies

From the painter's point of view, skies, being an integral part of landscape, are major subjects in themselves. They demand close observation and a degree of technical know-how, partly because of their infinite variety and partly because they are not subject to the same rules that govern the solid earth below.

A mountain, cliff, or tree will change in appearance under different lighting conditions, but its structure will remain stable, while clouds, seemingly solid but in fact composed of nothing but air and moisture, are constantly on the move, forming and re-forming in ways that can only partially be predicted and are never the same twice. Most important of all, the sky is the light source without which the landscape could not exist, and weather conditions above relate directly to the colors, tones, and prevailing mood of the land below. Thus, the surest way to spoil a landscape is by failing to analyze or express this relationship.

CLEAR SKIES
We tend to think of cloudless skies as simply blue, but in fact they vary widely according to the season and climate. A midsummer's sky in a hot country will be a warm blue, sometimes tending to violet and often surprisingly dark in tone, while a winter sky in a temperate zone is a paler and cooler blue. Nor is a clear sky the same color all over. A frequent mistake is to paint blue skies in one uniform wash, but there are always variations—sometimes slight, but often quite marked. As a general rule, skies are darker and warmer in color at the top and paler and cooler on the horizon, following the same rules of aerial perspective as the land. There is, however, an important exception to this. Sky directly over the sea will absorb particles of moisture, giving a darker band of color at the horizon, and a similar effect can often be seen in cities, where the dark band is caused by smoke, dust, or other pollution.

"LEARNING" CLOUDS
There are few people, whether they paint or not, who can fail to be enthralled by cloud effects—great, dark thunderheads, delicate "mackerel" skies, or the magical effects created by a low evening sun breaking through after a day's rain. Sadly, these effects are fleeting, so the landscape painter needs to be in constant readiness to watch, memorize, and sketch.

Making a Sky Look Interesting

Failure to paint skies convincingly often results from lack of confidence in handling a subject that is hard to pin down. Clouds are amorphous things, whose colors and shapes are apt to change even as you're painting them.

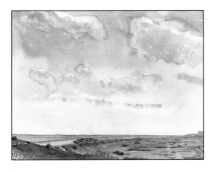

The painting above has its merits: The low horizon line is well placed, giving prominence to the sky, and there is a sense of perspective as the clouds become smaller and flatter as they recede toward the horizon. Overall, though, the picture is weak and tentative. The sky is obviously meant to be the center of interest, but it doesn't contain enough color or drama to draw the viewer's attention. The clouds are floating around in a disjointed fashion, and there is nowhere for the eye to focus.

In Stan Perrott's *Manitoba Skyscape* (page 176), the composition is similar to that of the problem painting above, with a low horizon line giving emphasis to the sky. But

there the sky is much more dramatic and forceful: The cloud grouping has a unity and cohesion that makes for a stronger, more dramatic image.

Painting skies effectively requires a combination of boldness and good planning.

PLANNING IS ESSENTIAL

Know what colors you're going to use at the outset and have them mixed and ready to use so you can work quickly and directly. Having to break off in the middle of a sweeping wash to mix up more paint is likely to prove fatal.

BOLDNESS

This means having the nerve to mix much stronger, richer pigments than you think you'll need. The color may look too strong when it's wet, but you'll be amazed at how much paler it appears when the wash has dried. Also, don't forget that the dark tones in the landscape will knock back the paler tone of the sky even more.

Boldness also means using large brushes, well loaded with paint,

and working quickly and loosely to inject a sense of movement into the sky. Be spontaneous: There's no point in trying to paint the sky exactly as you see it, since the shapes change so quickly, and if you try to fix them you end up with "concrete" clouds.

COMPOSITION

To create balance in a landscape painting, either the land or the sky must dominate. If you choose to emphasize the sky, make sure that it is composed well and contains a strong center of interest. The problem painting looks bland because neither the sky nor the land contains dramatic contrasts of shape or tone. In Stan Perrott's painting, on the other hand, the horizontal band of rolling clouds gives strength to the composition and provides an arresting focal point.

The trees' dark shapes echo and emphasize the cloud forms and provide a link between the blues of the sky and the greens of the landscape.

A low horizon line gives prominence to the sky.

The clouds are grouped and massed to form a strong, coherent shape.

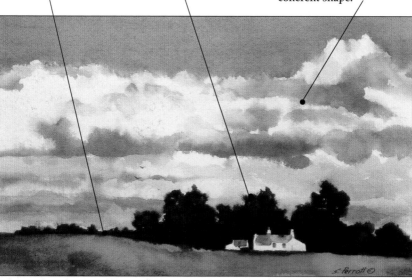

MANITOBA SKYSCAPE by Stan Perrott

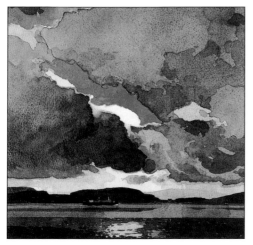

OUT OF OBAN by Ronald Jesty
This dramatic cloud study was painted in the studio from a pen sketch. Built up entirely by means of superimposed washes painted wet-on-dry, the colors are nevertheless fresh and clear. Although many watercolorists avoid overlaying washes for subjects such as these, which are easily spoiled by too great a buildup of paint, Jesty succeeds because he takes care to make his first washes as positive as possible.

MOONLIT MACKEREL SKY, FRANCE by William Lionel Wyllie
By making numerous quick studies of skies, like this one by William Lionel Wyllie, you will develop your powers of observation and analysis, as well as the technical skill required to describe the effects of light in the sky.

Cloud Formations

Clouds are always on the move — gathering, dispersing, forming, and re-forming — but they do not behave in a random way. There are different types of clouds, each with its own individual structure and characteristics.

To paint clouds convincingly you need to recognize the differences. It is also helpful to realize that they form on different levels, and this affects their tones and colors.

Cirrus clouds, high in the sky, are fine and vaporous, forming delicate, feathery plumes where they are blown by the wind. The two types of clouds that form on the lowest level are cumulus clouds, with horizontal bases and cauliflower-like tops, and storm clouds (or thunderclouds) — great, heavy masses that rise up vertically, often resembling mountains or towers. Both these low-level clouds show strong contrasts of light and dark. A storm cloud will sometimes look almost black against a blue sky, and cumulus clouds are extremely bright where the sun strikes them and surprisingly dark on their shadowed undersides.

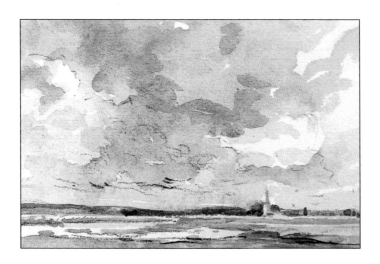

BOSHIP ESTUARY by Christopher Baker
The scudding clouds are painted lightly and deftly, with definition restricted to the few lines of crayon that formed the preliminary drawing.

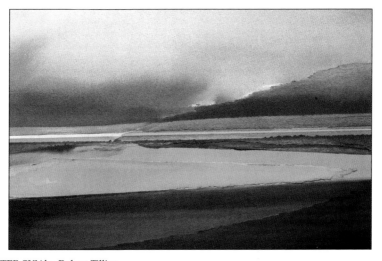

WINTER SKY by Robert Tilling
Working on a light, stretched paper with Not surface, and with his board well tilted, the artist used large brushes to lay very wet washes, later adding further ones wet-on-dry.

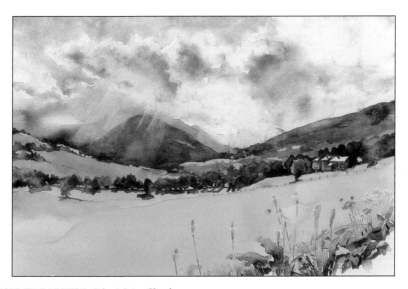

MOUNTAIN RETREAT by Moira Clinch
A variety of hard and soft edges gives form to the clouds. Color is scumbled and lifted out to give movement and a vaporous effect.

Light in the Sky

The great theatrical effects of light and color in the sky have produced some of the most magnificent and sublime works in the history of art.

Glorious sunsets, towering banks of sunlit cumulus clouds, dark, storm-filled skies, the feathery patterns of cirrus clouds against a clear blue expanse: These are the kinds of subjects that have attracted artists for generations.

The great landscape artist John Constable declared, "The sky is the source of light in nature and governs everything." Thus, the quality of the light in the sky will have a direct influence on the atmosphere and mood in your landscape paintings. Or, at least, it should. Inexperienced painters sometimes make the mistake of treating sky and land as two

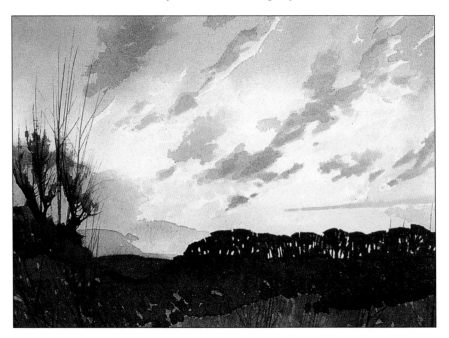

SUNRISE, NINE SPRINGS by Ronald Jesty
Ronald Jesty has captured one of those beautiful, accidental phenomena that make the sky a constant source of wonder and inspiration. The dark silhouette of the landscape accentuates the brilliance of the sky and focuses our attention upon the wonderful conformity of the clouds.

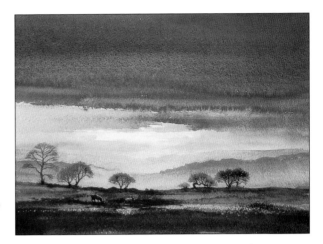

EVENING,
PANTYGASSEG
by David Bellamy
Here the artist has
interwoven the warm
pinks and golds of the
setting sun with cool
blues and violets of the
clouds and the distant
mountains, making the
warm and cool colors
vibrate against each other
to create a warm glow.

completely separate entities, resulting in a disjointed picture with no real feeling of light. Instead, try to bring the sky and the landscape along simultaneously, bringing some of the sky color into the land and vice versa.

It's also important to compare the tonal relationship between the clouds and the sky, and between the sky and the landscape. For example, the tones in the sky are almost always lighter than those in the land. If you see a dark cloud rimmed with light, this may look at first glance like the contrast between black and white. If you then look at the branches of a tree in dark silhouette in front of that cloud, you will see that the dark of the cloud suddenly appears, in this context, as a middle gray. Through this delicate balancing of tones you can capture the brilliance of the sky without it appearing to be an unnatural, conflicting, and separate entity within your composition. By relying on observation and analysis of this kind, you can paint the most extraordinary skies and find that they can be carried off with conviction, even if they appeared utterly improbable at first.

SUNSETS

Sunsets, with their rich, glowing colors, have always been a popular painting subject. It's tempting, however, to go a bit overboard with the hot pinks, reds, and oranges, and this can result in a corny, picture-postcard image if you're not careful.

In the painting above, for example, the colors in the sky have a synthetic appearance. Instead of conveying the tranquil mood that prevails at the close of day, the overall effect of this painting is somewhat jarring.

Snow Scenes

Fresh snow, the tops of cumulus clouds lit by the sun, and breakers at the seaside are among the whitest features to be found in nature. But even though their local color is pure or almost pure white, the colors we perceive stray dramatically from this depending on the lighting conditions, reflections from adjacent objects, and our own viewpoint.

In winter the sun is always low, and if the sun is shining from a clear blue sky, the areas of the snow being illuminated directly will appear bright white. If the snow is lying on undulating ground it will vary in color and tone depending on the exact angle in relation to both the viewer and the sun. Areas largely turned away from the sun will be mainly reflecting light from the blue parts of the sky, so they will appear bluish, and there may be shadows (long because the sun is low) that for the same reason will also be blue or blue-gray.

On a cloudy day the color of the snow will depend on the thickness of the cloud cover. When the winter sun filters through thick clouds, it is often quite yellow, and the snow often will reflect this color. There will, of course, be no clear-cut shadows, but shaded areas, hidden from the yellowish light, will take on something of the complementary hue of violet, together with various cool grays and purples.

In watercolor, bare white paper is the equivalent of white oil paint straight from the tube. Thin pale washes can be used to break up parts of this surface, and progressively darker colors can be added, ending with the darkest shadows. As always, nothing can beat looking, seeing, and experimenting.

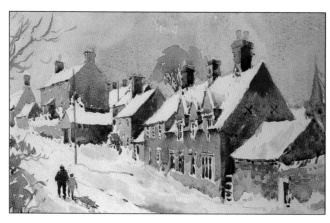

FIRST SNOW by Alan Oliver

People tend to avoid painting snow scenes on a cloudy day because they imagine they will be dull. Yet a winter landscape on a cold, bleak day has a stark beauty all of its own, in which the skeletal shapes of the trees make dramatic patterns against the snow and the sky.

Snow Lane (below) is highly effective in conveying the hushed stillness of a snow-covered landscape under a threatening sky. Using a limited palette of subtle grays and browns, plus the white of the paper for the snow, Keith

Andrew composes his picture in terms of light and dark tonal patterns that, in their austerity, convey the bleakness and coldness of winter. We also sense the power and grandeur of nature, represented by the tiny, muffled figure of the man set against the great, dark tree.

TONAL CONTRASTS

The beauty of a snow scene is that everything is reduced to striking patterns of light and dark. Look for opportunities to use strong tonal contrasts, such as the dark shapes of trees, walls, or buildings against the snow. On an overcast day, the tone of the sky is darker than that of the normal arrangement. In *Snow Lane,* notice how the darks of the trees and the white of the snow are intensified through contrast with the mid-tone gray of the sky.

HARMONIOUS COLORS

Use color to convey a mood and produce a harmonious image, rather than creating an exact replica of the scene. In his painting, Keith Andrew uses a restricted palette consisting of sepia, burnt sienna, ultramarine, and light red. This restrained use of color emphasizes the impression of coldness and stillness.

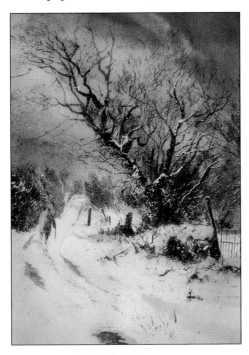

SNOW LANE by Keith Andrew

Landscape

Whatever the medium used, landscape is among the most popular of all painting subjects, and among watercolorists, particularly amateurs, it ranks as the undisputed number one.

One of the reasons for this is the common belief that it is easier than other subjects. Many who would never attempt a figure painting or flower study turn with relief to country scenes, feeling them to be less exacting and thus more enjoyable. This is perfectly understandable, and even quite a reasonable assumption; after all, it often does not matter too much if the shape of a mountain or tree is not a precise translation of reality. However, a painting will certainly be marred by poor composition or mishandled colors—these things always matter, whatever the subject. The best landscapes are painted by artists who have chosen to paint the land because they love it, and use the full range of their skills to express their responses to it, not by those who see it as an easy option.

DIRECT OBSERVATION

Another factor that separates the really good from the just adequate is knowledge, not just of painting methods but also of the subject itself. This is why most landscape painters work outdoors whenever they can. Sometimes they only make preliminary sketches, but often they will complete whole paintings on the spot. This, of course, is not always easy, but even if you only jot down some rapid color impressions, it is still the best way to get the feel of a landscape. If you use photographs as a starting point—and many professional artists do take photos as a backup to sketches—restrict yourself to a part of the countryside you know well and have perhaps walked through at different times of the year so that you have absorbed its atmosphere. Nature's effects are transient and cannot be captured adequately by the camera, so if you try to copy a photograph of a scene you are not familiar with, your painting is likely to have the same frozen-in-time look as the photograph.

Nor should you attempt to copy nature itself: Painting is about finding pictorial equivalents for the real world, not reproducing it in precise detail. This means that you have to make choices and decide how much to put in or leave out and think about whether you might usefully exaggerate a certain feature in the interest of art. For instance, you might emphasize the feeling of

space in a wide expanse of countryside by putting in some small figures in the middle distance, or convey the impression of misty light by suppressing detail and treating the whole scene in broad washes.

Watercolor seems to be almost tailor-made for landscape painting, as its fluidity and translucency are perfectly suited to creating impressions of light and atmosphere. Light and portable, it has always been popular for outdoor work, but until you have gained some practice, it can be tricky to handle as a sketching medium. There is always the temptation to make changes in order to keep up with the changing light, and if there is too much overworking the colors lose their freshness, defeating the aim of the exercise. There are ways of dealing

with this, however. One is to work on a small scale, using the paint with the minimum of water so that you cut down the time spent waiting for each layer to dry, and another is to work rapidly wet-on-wet, concentrating on putting down impressions rather than literal descriptions.

If watercolor proves to be too frustrating, you may find gouache a good substitute. It can be used thinly, just like watercolor, but dries much more quickly and can be built up in opaque layers for the later stages.

If you intend to complete a whole painting on location rather than just making sketches, it is a good idea, if the subject is at all complex, to make the preparatory drawing the day before. Once the foundation is laid, you can approach the painting with confidence the following day.

VIEW THROUGH THE VALLEY
This landscape illustrates the use of a classical technique. Full use has been made of atmospheric perspective, as the magnificent slopes in the foreground give way to the hazy blue tinge of the distant mountains.

The Effects of Light

Light will play an important part in determining the atmosphere of your painting, and watercolor, with its characteristics of fluidity and transparency, is a particularly suitable medium for capturing its effects.

As well as creating the general mood of a picture, light can also be responsible for dramatic effects, with strong light giving rise to deep, dark shadows or an unusual quality in the light being responsible for a weird and unnerving glow.

Geographical location is one of the major factors affecting the quality of light. Paintings that were worked on abroad show evidence of the hot intensity of southern light that is in marked contrast with the light coolness that emanates from pictures painted under a northern sky. The time of day is also important. The qualities of thin, early morning light, of midday sun high in the sky, or of a rich, warm evening light can totally alter the scene being painted. A midday sun produces short shadows with

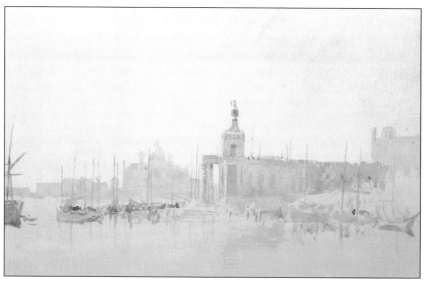

VENICE: PUNTA DELLA SALUTE by J. M. W. Turner

Many artists have a certain favorite theme or motif that appears in their work. For the English artist Joseph Mallord William Turner (1775–1851), that theme was light. And it was the magical effects of the light of Venice that had the most profound effect on Turner's work.

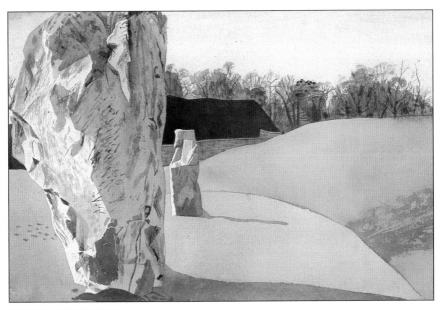

STONES AT AVENBURY

The artist chose the viewpoint for this painting with great care, wishing to impart a sense of the grandeur and timelessness of an ancient monument. This is achieved by placing the dominant form of the large stone directly in the foreground to fill the picture plane from top to bottom. The cool tones of washed-in color express both the clarity of daylight and a sense of spaciousness that echoes the perspective provided by the stones. The texture of the stone is detailed with a limited range of color and contrasts well with the flat washes corresponding to the broad expanse of grass.

objects lit from above, whereas a sinking or rising sun will produce long shadows with warm or cool tones.

General weather conditions will, of course, affect the quality of light; for instance, a cloudy and overcast sky with a dull, thin light and dramatic clouds with strong shafts of light piercing through. Dramatic weather conditions do not appear on demand, and certainly not if you are anxiously waiting for a thunderstorm or a thick fog. It is advisable, therefore, always to be prepared, perhaps by carrying a sketchbook and small box of paints if you are traveling by car. Even an ordinary notebook is extremely useful; dramatic weather conditions can be quickly recorded and copious notes made so that a finished watercolor can later be painted in the studio.

Perspective and Proportion

If you want to make detailed, accurate, and highly finished paintings of complex architectural subjects, such as Victorian mansions and cathedrals, a knowledge of perspective is vital, as are sound drawing skills.

This is a specialized kind of painting, but most people have humbler aims, and it is perfectly possible to produce a broad impression of such subjects or a convincing portrayal of a rural church, farmhouse, or street scene mainly by means of careful observation. Too much worrying about perspective can actually have a negative effect, causing you to overlook the far more interesting things, such as a building's general character, color, and texture. However, there is one important rule that most of us learn at school but don't pay much attention to, and this is that receding parallel lines meet at a vanishing point on the horizon. The horizon is at your own eye level, so is determined by the place you have chosen to paint from. If you are on a hill looking down on your subject, the horizon will be high and the parallels will slope up to it, but if you are sitting directly beneath a tall building, they will slope sharply down to a low horizon. It is vital to remember this when painting on the spot, because if you alter your position by, for example, sitting down when you began the painting standing at an

easel, the perspective will change, and this can be disconcerting.

If you intend to paint a portrait of a particular building, shape and proportion are just as important as they are in a portrait of a person—it is these that give a building its individuality. A common mistake is to misrepresent the size and shape of doors, windows, and balconies in relation to the wall area, which not only makes it fail as a portrait, but also creates a disturbing impression, as the building looks structurally impossible.

Before you start to draw or paint, look hard at the building and try to assess its particular qualities. Some houses are tall and thin with windows and doors occupying only a small part of each wall, while others seem to be dominated by their windows. In a street scene there may be several completely different types of buildings, built at various times, and all with distinct characters of their own. You can exaggerate these for extra effect, but you ignore them at your peril.

Shapes and proportions can be checked by a simple measuring system. Hold a pencil or a small

pocket ruler up in front of you and slide your thumb up and down it to work out the height or width of a door or window in relation to those of the main wall. Most professional artists do this; the human eye is surprisingly untrustworthy when it comes to architecture.

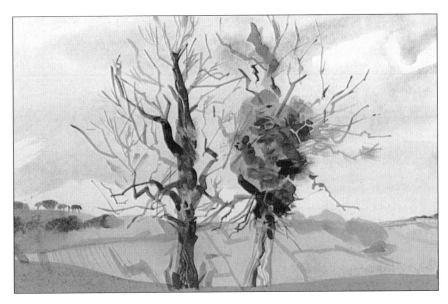

The painting shown above captures a sense of distance by showing how the land recedes gradually from the foreground toward the horizon and uses the two trees as a central focus. This is achieved by carefully varying color tones—placing strong, warm hues in the foreground and colors that are cooler and less intense in the distance. The impression of receding space is enhanced by the sky gradually lightening and finally rising into a thin strip of white.

To keep an overall coherence to the picture, the colors in each area are subtly linked together. For example, the same blue has been used for the linear details in the middle distance as in the shadow areas of the trees. A harmonious balance of warm and cool tones has been applied, as seen in the contrast between the warm brown of the foreground, the colder yellow across the center of the painting, and the reddish-brown and blue tones in the trees that deepen the intensity of the green washes. The end result is a striking, dramatic, and yet beautifully balanced picture.

Architecture

When painting urban landscapes or buildings in general it is essential to have a fairly thorough knowledge of perspective. Rectangular, man-made forms require a believable and more solid realism than the softer, less easily defined features of a landscape.

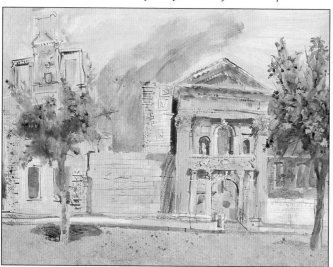

ROMAN FACADE

Even drawing from an upstairs window will be more difficult than working from ground level; establishing your eye level is important. The handling of the Roman building, however, is more akin to that used for natural forms; the freedom of splatter, pastel, and pen and ink work is not immediately recognized as being suitable for such a classic, restrained subject.

In the painting *Roman Facade* (above), the initial drawing has been carried out accurately. The shapes and forms are closely related and although there is freedom within the work, every window, column, and carving has been judiciously considered and placed. The perspective used here, however, is fairly simple, the trees and pavement giving the initial clues to the three-dimensional element.

A rooftop view would require greater knowledge of perspective.

The color of a townscape can be infinitely subtle and stimulating, with varying grays, brick reds, and the white of stonework providing a harmony. Try to capture also the bustling pace of a town and the movement of people and cars. The light of townscapes is very different from that of the country. Instead of light being flooded over a whole

area with the sun being diffused only by the atmosphere or by clouds, buildings act as obstacles and create interesting and even dramatic lighting effects. On the brightest of days tall buildings can trap shafts of sunlight so that one side of the street can be in sunshine, the other deep in shade.

The intimacy of narrow, winding streets and passageways can provide the focus for your painting; ancient buildings and modern skyscrapers can throw up strange and interesting contrasts in scale, architecture, social comment, and juxtaposition of shapes. Within your local town, search out areas of interest for painting; a church, the marketplace, a riverside, and docks or wharves.

One problem that you may encounter is the practical one of setting yourself up. A crowded street is no place for a portable easel, and in most urban locations you will have to make do with a sketchbook.

DOORWAY
To achieve the crisp detail of form and decoration in this painting, a pencil drawing was made to form the basis for the addition of color. All the lines, shapes, and proportions were carefully considered and realized in the drawing before the initial washes were laid. To maintain this standard of precision, each area of wash was allowed to dry before more color was added. This can be a time-consuming process, so when you approach a subject requiring a similar technique, arrange to work from all sides of the drawing, turning the board to fill in a section opposite a newly laid wash. Take great care not to let your hand rest on paint that is still damp, as it is difficult to disguise smudging and unintentional variations in tone in works requiring such accuracy.

Portraying a Bright, Sunny Day

When painting a scene bathed in bright sunshine, many beginners underestimate the often very strong contrasts of light and shadow that occur. Working outdoors, one is easily blinded by the bright sunlight, which makes it difficult to judge colors and tones accurately.

A painting that seemed vibrant and colorful at the time it was painted often looks disappointingly flat when examined again later.

The composition of the painting above is basically very good, with the building on the left forming a frame for the scene beyond. The only problem is the overall lack of contrast between the warm, sunlit areas and the cool shadow areas. The trees on the right, for example, are an uncertain mass of muddy greens, with no feeling of light filtering through the foliage. Had the artist thrown a deep, luminous shadow across the foreground and accentuated the lights and darks in the middle ground, the picture would have been much more exciting and vibrant.

When composing a sunny scene, remember that either the bright, warm areas should dominate, or the cool, dark shadow areas. If there is an even spread of lights and darks, the effect of bright sunshine will be lost. The problem painting, for instance, lacks atmosphere because the colors are too similar in tone and intensity. Compare this to *Dappled Garden Path* by Lucy Willis (opposite), in which dark tones predominate, yet the overall impression is one of sparkling sunshine.

SHADOWS

It may sound like a contradiction, but shadows play an important role in conveying an impression of bright sunlight. In *Dappled Garden Path* the foreground trees are mostly in shadow and we glimpse a small, sunlit patch of garden behind them. Because it is surrounded by dark greens, this warm, bright area appears the more intense and our eye is automatically drawn to it; thus it forms the focal point of the picture.

WARM AND COOL

Everything the sun hits becomes warmer and more intense in color, whereas objects in shadow are correspondingly cool. Adjacent warm and cool colors have the effect of intensifying each other, and this creates a luminous glow of sunshine. Remember this when mixing your colors. Don't just think "green"; think, "Is that a warm green or a cool green?" Examine Lucy Willis's painting and see how she weaves a pattern of warm and cool color throughout the composition.

DAPPLED
GARDEN PATH
by Lucy Willis

• SUBJECT •

People in Landscapes

The vast majority of landscapes contain no figures — and are none the worse for it. But from time to time you'll come across a subject that does include people — whether it is a bustling street market or a lone fisherman by a stream.

Figures in a landscape offer many advantages. Their size in relation to their surroundings lends a sense of scale, and they can draw attention to the focal point of the composition, or even become the focal point themselves.

"That's fine," you might say, "but I can't paint figures." However, for the purposes of a landscape or street scene, a detailed figure study is not what's required. What is important is capturing the attitudes and gestures of the people you're painting. In the painting below the figures are rendered very simply —

they're barely more than strokes and dots — yet they convey all the noise and color of a busy street in France.

Carry your sketchbook with you everywhere, and make sketches of people in cafés, parks, and shops — any place where people gather together and you can sketch them without attracting too much unwelcome attention. Keep the sketches small, and aim to capture the bearing and shape of your subject. Notice how the movement of clothing affects the shape of a figure in action. Pay attention also to the shadow masses — these are important in conveying an impression of the figure's weight and solidity. Even if you only make one or two sketches a day, you'll be surprised at how quickly the natural forms of the figures become second nature to you.

EYMET, FRANCE
by Geoff Wood

Adding Foreground Interest

In any landscape painting the foreground is often the trickiest part to handle. Include too much detail and you discourage the viewer's eye from moving back in the picture plane and exploring the rest of the composition. Put in too little detail, on the other hand, and the foreground becomes an empty, monotonous area.

Foregrounds need to be handled carefully. The trick is to be able to suggest detail and texture without overstatement, so that the viewer is aware that there are shadows on the grass, flowers in the field, or whatever, but does not have these details forced upon him or her. In other words, you have to mimic the way in which the human eye perceives things: When we focus on one particular object, the area around that object is seen more or less as a blur because the brain can only take in so much visual information at one time.

In the painting below, the artist uses subtle modulations of color, texture, and tone to create a lively impression of the field in front of the house. These subtle details are pleasing to the eye, but they don't detract from the focal point of the picture, which is the group of farm buildings in the distance.

If you have a large expanse of foreground, keep it lively by varying the tones and colors. This will encourage the viewer's eye to move around the picture space. In *Farm House at Richmond*, Stan Perrott painted the grass wet-on-wet and lifted off some of the paint with a damp natural sponge and blotting paper to create light areas.

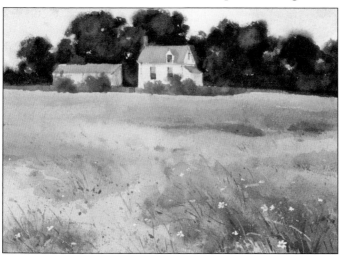

FARM HOUSE
AT RICHMOND
by Stan Perrott

Water

Clear, clean water, like glass, allows us to see through to whatever is at the other side, usually the mud, sand, or rocks below it.

If the water contains suspended mud or vegetation, then the water takes on its own color—for instance, mountain streams are often brownish because the water is colored by peat, while the sea in some places is greenish-brown from the algae in it. Water also reflects light at its surface, and thus acts as a mirror. For painting purposes,

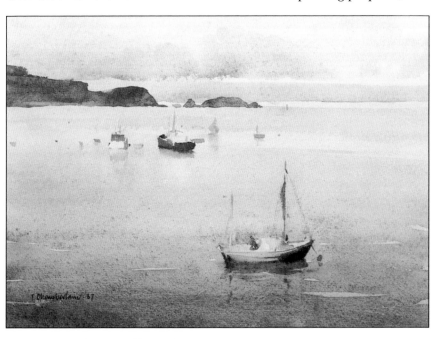

STILL EVENING by Trevor Chamberlain
Broad washes of watercolor have been used, with the minimum of color variation. In some places the paint has been used wet-on-wet, causing the colors to mix by bleeding into one another. This can be seen in the clouds, and in the water just behind the distant boat. In the foreground, washes have been laid over dry paint, leaving small, clearly defined lines of lighter color, suggesting the light catching on a gentle swell. Because the water is so calm, it is almost the same color as the sky, but it is not a flat area of tone; notice how it gets much darker toward the foreground.

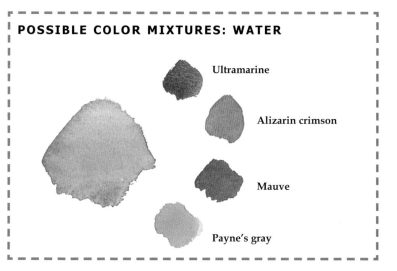

POSSIBLE COLOR MIXTURES: WATER

Ultramarine

Alizarin crimson

Mauve

Payne's gray

these are the three important points to remember. It is the reflections that usually play the most important part in contributing to the appearance of water in a landscape or seascape. Unlike a mirror, the strength of reflection increases in proportion to the degree of slant with which you view the water. A calm lake in the distance reflects almost the entire sky — if the sky is blue, the lake is blue; if the sky is gray, the lake is gray. In contrast, if you look down from a bridge into a slow-flowing river, most of what you see is the river bottom or mud suspended in the water, with possibly a weak reflection of yourself and the sky above. Thus, any stretch of smooth water becomes lighter with distance as it reflects more sky.

Nearby areas of water may be reflecting buildings or trees, but the same principle applies.

The reasons why choppy water is so difficult to observe, and therefore to paint, are threefold. The first thing you have to take into account is the shapes of the waves or ripples, the second is their color, and the third is the fact that the water simply will not stay still. Look carefully to see what is being reflected — this is always vertically above the reflection. The color of the reflection is always a little duller than the original, so add a little raw umber or Payne's gray. Each wave or ripple will be reflecting more than one color, but don't try to be too precise; these are usually adequately represented in paint by interspersing horizontal patches of color.

Still Water

The secret of painting water is to edit out all the superfluous details and go for the bigger masses of tone and color.

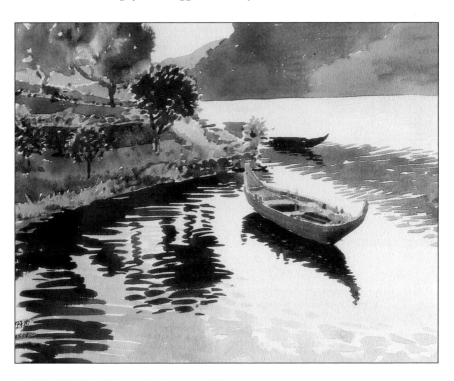

BOATS ON THE RIVER DOURO by Lucy Willis

In the painting above, the artist leaves much of the paper bare and puts in just a few telling ripples and reflections, which are all that's needed to show the water.

You've probably heard the saying "Less is more," and nowhere does this apply more readily than in the painting of water. Achieving the smooth, glassy look of water requires surprisingly little effort; often a few sweeping strokes with a broad brush on damp paper are enough to convey the effect you want. Yet beginners often seem to think that there must be more to it

Smaller, denser ripples indicate water receding into the distance.

Ripples are larger and more broken in the foreground. Expressive brushstrokes give a sense of movement.

Sharp contrasts of tone between water and reflections give a glassy look to the water.

than that, and insist on putting in a few odd streaks and ripples here and there for good measure.

Whether you apply your colors to dry or damp paper is a matter of preference, but here's one important piece of advice: Choose your colors with care and apply them with confidence. The more decisively and simply you paint water, the wetter it looks, so try to work with large brushes that discourage the habit of fiddling and prodding, and use plenty of water to facilitate smooth, even strokes. Mix your colors carefully on the palette and test them on scrap paper before committing yourself, remembering that they should appear quite dark in tone to allow for the fact that they will fade a lot on drying.

Rapid Water

The problems involved in painting water are multiplied about ten times when it comes to painting rapids, waterfalls, and fast-moving streams. There's so much action going on, it's difficult to know where to begin.

Moonriver, Ontario by Ronald Jesty (below) demonstrates how a loose, direct approach can be very effective in rendering rapid water. Here, the white of the paper does much of the work in conveying an impression of water foaming and churning over the rocks; surprisingly few strokes of color are needed to complete the image.

Remember that rapid water looks more realistic when it's understated. Concentrate only on the major lines of motion—the ones that capture the essence of the water's movement. Don't allow yourself to be distracted by unimportant details that will clutter up the picture and destroy the illusion of movement.

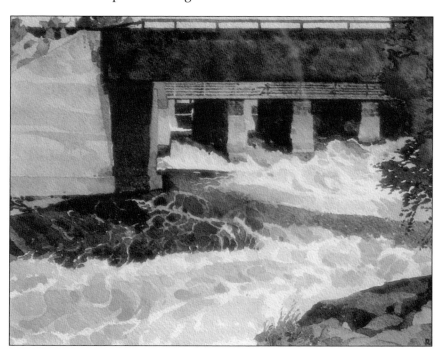

MOONRIVER, ONTARIO by Ronald Jesty

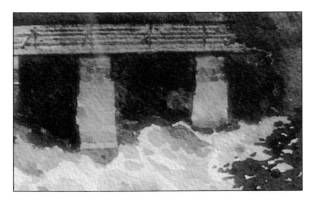

Surrounding solid shapes make the water appear more fluid through contrast.

Note the water's subtle color and how the white of the paper is used to represent churning foam. Strong, calligraphic brushstrokes capture the churning movement of water.

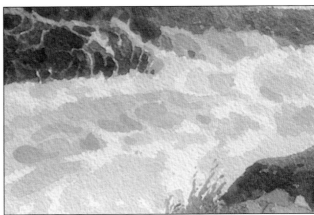

To paint fast-moving water well requires fast-moving brushstrokes. One deft squiggle can convey far more than any amount of hesitant goings-over, so take your courage in both hands and allow the brush to follow the movements of the water. Notice how Ronald Jesty uses strong, rhythmic brushstrokes to impart a sense of movement and encourage the eye to follow the progress of the water as it rushes over the rocks.

Often, the best way to emphasize something is by contrasting it with its opposite. In *Moonriver, Ontario,* note the contrast between the water, which is painted with thin paint and very light tones, and the surrounding landscape elements, which are painted with more definition and stronger tones. These dark tones and solid shapes make the water appear more fluid and fast-flowing through the confident use of contrast.

Reflections

When painting a watercolor, the main difference between a landscape and a seascape is that water reflects the sky above, which means that the normal tonal values will be reversed.

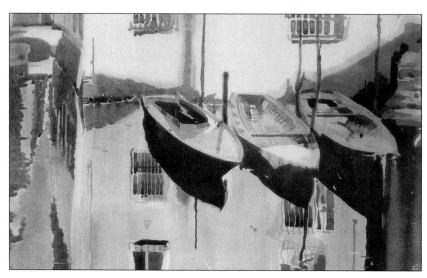

REFLECTIONS OF VENICE by Geoff Wood

It takes more than merely recording facts to infuse a painting with life. You must first of all pinpoint what it is that attracts you to a particular scene, and then orchestrate everything in the picture to put that across.

Reflections of Venice (above) demonstrates how a fresh and unusual approach can create a striking image that makes us look anew at a familiar subject. We are used to seeing paintings and photographs of Venice that show its grander side, but this painting stops

us in our tracks because it gives us a different, more intimate glimpse of this lovely city. The artist, Geoff Wood, has a particular fascination for painting reflections in water. He also loves Venice, and these twin passions come through loud and clear in his study of a quiet canal with its limpid reflections of pink buildings and moored boats.

Don't settle for the safest, most obvious viewpoint. Choose one that expresses your feelings about the subject. For example, a solitary, distant building placed in a vast landscape can evoke an atmosphere

of loneliness and isolation, whereas a close-up view of a flower allows you to express something about its color or the delicacy of its petals. Look at your subject from different angles to see which aspect clicks with you.

Often a painting fails because we've set ourselves an impossible goal. We trudge off into the countryside in search of some idealized "perfect spot" for painting, only to return home empty-handed at the end of the day feeling like the angler who didn't get a catch. Yet it's the simple everyday things, right under our noses, that often make the best paintings. If you want your paintings to be inspiring, paint what interests you, not what you think you ought to paint. Painters who are keen gardeners, for example, will find a wealth of inspiration in the greenhouse or potting shed as well as in the garden. Perhaps you have a favorite room in the house — one that always catches the sun or is filled with fond memories. Why not paint it? Because it is something you love, you will instinctively put more of yourself into the painting.

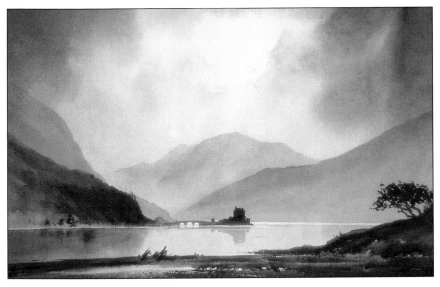

LOCH DUICH by David Bellamy
Interpreting your subject often means having to think laterally. Instead of copying what you see, use your creative skills to translate what you see into a more powerful image. In this painting, for instance, David Bellamy evokes an eerie, almost sinister atmosphere by reducing all the colors in the landscape to shades of gray.

Seascape

The various moods of the sea provide the artist with a very different challenge from that of painting a landscape. The changing seasons bring tremendous fluctuations between wild, threatening waves and strong winds and the balmy airs of a warm summer's day.

As well as trying to capture the moods of the sea, the watercolorist may choose to depict figures, either people on a beach or fishermen, or items such as the Victorian amusement piers that still exist in some of the more popular seaside towns. The cozy harbor walls of a fishing village, the lighthouse atop a cliff, or seaside resorts can all contribute to atmosphere. The landscape near to the coastline also offers plenty of scope—towering cliffs, sandy coves, rocky bays, and flat sand dunes.

When selecting your subject, think of what it is that attracts you to a particular theme and consider the best way of recording your reaction and the materials most suitable for depicting your chosen topic.

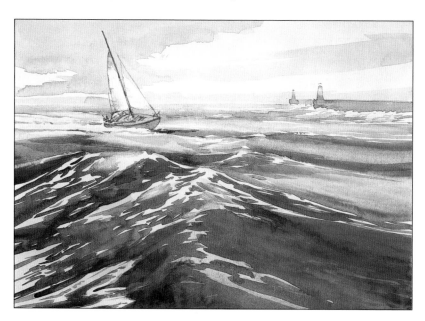

SAILING OFF TYNEMOUTH by Jason Skill

TECHNIQUES

A variety of techniques is appropriate for seascapes, but a wet technique is naturally more appropriate and easier to handle, as it reflects the character of the water and allows for the freedom and fluidity for which you may be searching. Be careful, however, not to get carried away by the beauty of your wet washes. Too much color added too quickly can result in a muddy, nondescript wash; sometimes it is better to allow washes to dry before adding any more color.

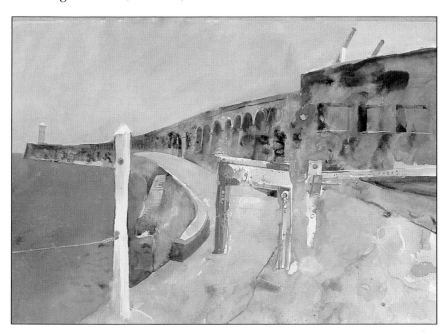

NEWHAVEN PIER

Here the paint is applied freely with loose areas of bright color melting together. Even a relatively inactive area like the sky, where only one color was applied, is treated vigorously with broad, sweeping brushstrokes. To create an interesting focal point, the rusting metal structure in the harbor wall is brought forward and emphasized with clarity in form and color. It may often be necessary to select from a natural view and alter the relationships of the components slightly, even abandoning those aspects that interfere with the development of a satisfactory composition.

PRACTICAL CONSIDERATIONS

All the examples of seascapes shown here were painted in places reasonably accessible by car, but often you will find that walking is the only way of reaching your destination. Clifftop walks encumbered by easel and materials can lead to accidents; make sure that you carry the minimum on your expeditions. Be prepared in particular for gusting winds and make certain that you weigh or pin down any loose paper or precious sketches.

CORNISH HARBOR

BREAKWATER AT LYME REGIS

The vivid blue line of the railings running horizontally across the picture (below) balances the sharp diagonal thrust of the breakwater. Color is handled very subtly to evoke the stony beach and graying water and extra depth is drawn from an underlay of warm brown that forms the basis of the other washes. The converging lines of the breakwater itself conveniently depict the distance from front to back of the picture area.

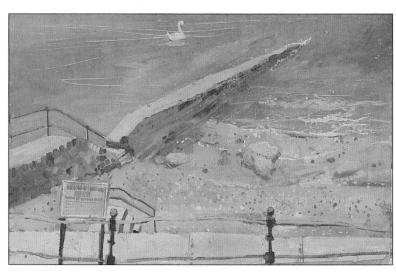

LANDSCAPE WITH BARRED GATE

Small areas of wash, overlaid one on another, dry brush technique, and delicate drawing with the point of a sable brush are combined in this painting on board to produce the richly textured effect. The tracing of white lines is in some cases due

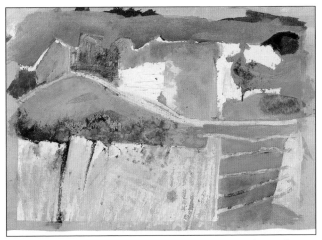

to the support being left bare, but the artist has also gently scratched into the surface with a knife blade. Masking fluid is an effective way to protect narrow lines from being flooded with paint and does not damage the paper surface, as may happen if a blade is used. The richness of the dark tones is due to washes of purple under the greens and browns.

VIEW ACROSS THE CLIFF

Individual forms in this landscape have been reduced to the barest essentials of color and texture. The composition has an abstract quality that is nevertheless evocative of the scene because the basic spatial relationships have not been altered. Wax resist and masking fluid have been freely used to draw rich texture into the washes of color and break up the broad surface areas.

Portrait and Figure Work

Figure painting in watercolor has a reputation for being difficult, if not downright impossible. But, as so often happens in watercolor, the biggest difficulties usually arise from the artist's lack of confidence and an unwillingness to let go and allow the medium its fullest expression.

Watercolor is commonly believed to be suited only to certain subjects. It is perfect for landscapes, of course, and effective for flowers, but surely it is much too uncontrollable to be brought to the service of figure and portrait painting. It is true that there is no strong tradition of figure work in watercolor and that all the most famous paintings of people—those we see in art collections—are in oils, but this has nothing to do with any inherent unsuitability of the medium. The reason for the choice of oils is much simpler. In the past, most paintings were done for a fee, and the artists had to please their patrons. Those who were wealthy enough to commission a portrait or pay a high price for a nude study wanted a large, imposing painting that would stand the ravages of time, and this meant using oils.

Nowadays, however, we paint for ourselves and do not have to produce highly finished works with every hair or jewel described in faithful detail. More and more artists are finding that watercolor is a marvelous medium for figure and portrait work, ideal for freer, more impressionistic treatments, and perfectly suited for capturing impressions of light and the delicate, living qualities of skin and hair.

9:30 A.M.
by Joan Heston

MOTHER
AND CHILD
by Greta Fenton
This lovely image should disabuse us of the notion that figures cannot be painted in watercolor. In the right hands it is the perfect medium. The artist has painted directly from life, working mainly wet-on-wet with a large Chinese brush and red crayon.

DRAWING

No branch of painting is problem-free and, because watercolors cannot be reworked and corrected to any great extent, it is vital to start painting on a good foundation. This means that before you can paint figures or faces successfully you must first be able to draw them.

The best way to approach the complexities of the human figure is to see it as a set of simple forms that fit together—the ovoid of the head joining the cylinder of the neck, which, in turn, fits into the broader, flatter planes of the shoulders, and so on. If you intend to tackle the whole figure, avoid the temptation to begin with small details; instead map out the whole figure first in broad lines.

Proportion is particularly important, and many promising paintings are spoiled by too-large heads, or feet that could not possibly be used for walking because they are much too small for the body. The best way to check proportions is to hold up a pencil to the subject and slide your thumb up and down it to measure the various elements. This will quickly show you the size of the hand in relation to a forearm and the ratio of head width to shoulder width.

Another way to improve your drawing is to look not at the forms themselves, but at the spaces between them. If a model is standing with one arm resting on a hip, there will be a space of a particular shape between these forms. Draw this, not the arm itself, and then move on to any other negative shapes you can see. This method is surprisingly accurate.

Female Figures

Much good figure painting in watercolor is fresh, simple, and vigorous.

With oils or acrylics, figures may be carefully worked up and refined over a long period of time, but a watercolor is often done quickly, on the spur of the moment when a suitable opportunity presents itself, avoiding the stiffness that can result when a great deal of thought is given to presenting a person in static pose. By working quickly, the character of the figure is summarized, relying as much on good judgment of tone and color and a confident approach as on perfectly drawn accuracy.

Do not worry too much about your ability to depict problem areas. Hands and feet are traditionally difficult subjects, and there is no point trying to hide them because the eye of the viewer will seek them out automatically. It is much better to make an honest attempt at painting everything, not only because through practice you will eventually improve but also because details treated with care and sensitivity and, above all, with confidence, will improve any work.

SELECTING A POSE

Many watercolors of figures are not posed at all but are painted simply when the opportunity arises and the subject happens to be standing or sitting in a suitable position. If you set out deliberately to draw a particular person, as in the case of *Pregnant Woman*, take some time to observe your subject and see if any characteristically personal poses recur. Here the artist was anxious to record the shape and form of a swelling belly, so a side view was chosen. An unpracticed model may find it difficult to hold a pose for any length of time, so care must be taken to make sure that the chosen stance or action is a fairly natural one. In the paintings on these two pages the model herself suggested the poses. They are relatively quick and unstudied pieces that serve as documentation but are also interesting in their own right.

Female figures generally have a softer, rounder feeling to their forms that shows both on the surface, when drawing nudes, and through clothing. Before starting to paint, examine the interplay of the parts of the body. It is important to note the way that the head sits on the neck and how the breasts affect the balance of the pose; the tilt of the hips influences the angle of the shoulders and the general stance. In a standing pose, look for the center

of gravity; this will help to establish the figure firmly on the ground.

The classical shape for the female figure is of a triangle, wider at the base to accommodate the hips and narrowing toward the shoulders; this is a useful guideline. The proportions of the head and face differ from those of men and children; the forehead will be gently rounded, the mouth smaller, and the eyes larger than those of the male, who will be more likely to have a protruding jaw, deep-set eyes, and a harder line to the forehead.

PREGNANT WOMAN

The interior again plays an important part in the composition of this painting, the delicacy of the curtains providing an interesting backdrop and the light again coming from behind. Although the curtain appears complex, the effect can be achieved quite simply: A wash of Payne's gray covers the wall area and the underpainting on the figure itself leaves white paper to indicate highlights.

Male Figures

When drawing men, many of the factors to be considered are the same as when drawing the female figure.

There are, however, obvious anatomical and character differences that will be reflected both in the physical form of the pose and the environment. Here, men are shown engaged in typically male pursuits.

PHYSICAL FEATURES

In general, a man's body is more muscular than that of a woman's, with the classic triangular shape of the woman being inverted so that the shoulders are wider than the hips. Such a generalized summary is, of course, denied by the existence of men where fat hides the shape of the skeleton or, for instance, by the sort of frame where slim hips are parallel with small shoulders.

The classically handsome man has a strong jawline, wide mouth, and angular, sloping forehead that will identify him as being characteristically male. The fact that many of the men you paint do not conform to this ideal should not prevent you from making use of this generally useful guideline.

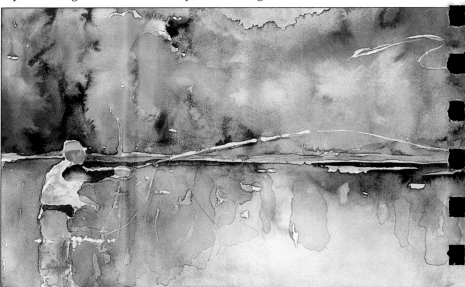

OARSMEN (above)

This painting is a fine example of complex problems skillfully solved. The greatest difficulty in drawing or painting any active sport lies in capturing the movement. Another difficulty tackled is that of painting water. It is important to know what to leave until last — reflections have to take their cue from solid forms and in this case the reflections of the figures cannot be put in until the oarsmen have been painted.

FISHERMAN (left)

The rich backdrop for this solitary fisherman was created by applying wet pools of color and allowing them to flow together. Smaller areas of wash were laid into the paint when partially dry. Jagged shapes suggesting foliage occur naturally by an intense concentration of color at the edge of a drying wash. It provides a dense ground cover over which the looping fishing line provides a flicker of movement.

Eyes and Mouths

*One of the most common mistakes in portrait painting is rendering the facial
features too tightly. The tendency is to draw outlines of the eyes, nose,
and mouth and then fill them in with color, often painting
the surrounding skin tones last of all.*

PORTRAIT OF A YOUNG GIRL by Sally Launder

the mouth turn up;
you must also make
the eyes, cheeks, and
jaw smile.

The best way to
approach painting
faces is to work from
the general to the
particular, rather as a
sculptor begins with
roughly hewn shapes
from which he
gradually carves out
the smaller details.

In *Portrait of a
Young Girl*, the girl's
face is fresh, mobile,
and lifelike. Rather
than finishing the
eyes and then
moving on to the
nose, Sally Launder

The eyes are the most prominent
feature of the face, but beginners
often give them too much emphasis.

The eyes, nose, and mouth
should not be stuck onto the surface
of the face. The bones and muscles
that lie beneath the skin are all
interconnected, so painting a
smiling face, for instance, is not just
a matter of making the corners of

worked over the whole face at
once. That way, she could better
judge the relationships between the
features and make any necessary
adjustments as she went along.

Eyes are not difficult to paint
once you understand how they are
constructed. The eye is not a flat
disc—it is basically a sphere that sits
inside the upper and lower eyelids,

not resting on their edges. Also, the whites of the eyes are not a uniform, stark white. Because the eyeball is round, the whites of the eyes pick up shadows and reflections from their surroundings.

The fatal error when painting mouths is in drawing an outline and filling it with color, which gives the mouth a flat, pasted-on appearance. The correct technique is to sculpt the form of the mouth, creating soft masses of light and dark tones that blend softly together. In the painting on the opposite page, the edges of the mouth blend naturally into the surrounding flesh, with just a hint of a crisp edge where the top line of the upper lip is caught by the light.

A smiling mouth is more difficult to paint than a mouth in repose, as any undue exaggeration of the smile results in a caricature rather than a portrait. The essential thing to remember is that we smile not only with our mouths but with our entire faces. Cover up the mouth in this portrait and you will see that the girl is still smiling. This is valuable proof that all the features of the head are interlinked and supportive of one another.

Obviously it would be difficult for a model to hold a smiling pose for a long period without the smile becoming somewhat fixed. In this case, it might be helpful to take snapshots of your model and use these as reference during the painting of the portrait.

Here, the color on the shadow side of the face is darker, with further washes that accentuate the light-struck planes of the left side of the face.

• SUBJECT •

215

Birds and Animals

This is a challenging and absorbing subject for the still life artist and watercolor is a particularly suitable medium, being easily portable for use in the field.

The medium should not be restricted to the ornithological enthusiast making visual notes of his sightings; watercolor is an invaluable aid to identification or can be used to put in areas of local color or create an atmospheric impression. Used in the studio, watercolor is the ideal medium for making careful copies of natural features such as plants, rocks, and shells or birds and other animals.

FEATHERS

In most birds, the wing and tail figures are quite smooth and precise in shape, while those on the neck and throat have a downy quality. Begin by painting the bird with a pale underwash. Then use a small, soft brush to delineate the markings of the main feathers, working wet-on-dry to achieve a precise pattern. The soft, downy

In this dramatic study of an owl in flight, the artist uses very loose brushstrokes, which not only captures the texture of the feathers but also accentuates the impression of flight.

For obvious reasons, it can be difficult to study birds from life, but working from a photograph is not always satisfactory. In this particular case, a high-quality photograph provided a ready-made composition, but the artist also made studies of a dead owl that he had found, so he could record the coloring and arrangement of the feathers more accurately.

feathers should be added last, using light, scumbled strokes.

OBSERVING MOVEMENT

Watch an animal carefully and you will notice that the movements it makes, although they may be rapid, are not random—they have certain patterns. If you train yourself to make quick sketches whenever possible and take photographs as an aid to understanding, you will find that painting a moving animal is far from impossible—and it is also deeply rewarding.

We in the modern day are lucky because we benefit from the studies and observations of past generations. We know, for instance, that a horse moves its legs in a certain way in each of its four paces—walking, trotting, cantering, and galloping—but when Edgar Degas (1834–1917) began to paint his marvelous racing scenes he did not fully understand these movements. He painted horses galloping with all four legs outstretched, as they had appeared

WATERBIRD

Here, a photograph of a bird wading in the shallows provided a ready-made composition. The reflections do not have to be very exact, but the vertical has to be right below the part that is reflected.

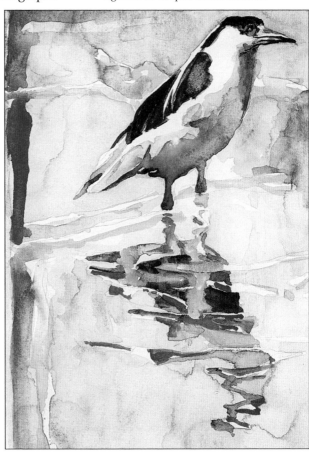

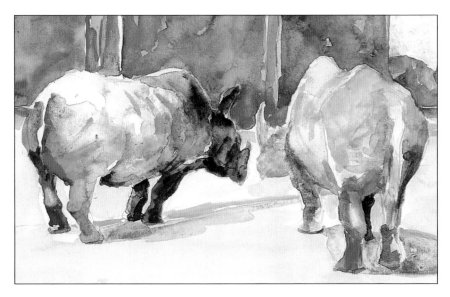

RHINOCEROSES
Fortunately, rhinoceroses are slow-moving! The background is an important element in this painting and the final effect has been arrived at not by starting out with any preconceived ideas as to how it should look but by experimenting with colors and shapes until an interesting result has been achieved.

in English sporting prints. It was only when Eadweard Muybridge (1830–1904) published his series of photographs of animals in motion in 1888 that Degas saw his error and was quick to incorporate this newfound knowledge into his paintings. This points up the value of the camera as a source of reference, but photographs should never be slavishly copied, as this will result in a static, unconvincing image—photographs have a tendency to flatten and distort forms and "freeze" movement.

UNDERSTANDING THE BASICS

Painters and illustrators who specialize in natural history gain their knowledge in a wide variety of ways. Many take powerful binoculars and cameras into remote parts of the countryside to watch and record birds and animals in their natural habitats, but they also rely on illustrations and photographs in books and magazines or study stuffed creatures in museums.

All this research helps them to understand basic structures, such

as the way a bird's wing and tail feathers lie or how a horse or cow's legs are jointed. In the past, artists were taught that a detailed study of anatomy was necessary before they could even begin to draw or paint any living creature. Some wildlife painters, whose prime concern is scientific accuracy, still do this, but for most of us this depth of study is unnecessary.

SKETCHING FROM LIFE

Although background knowledge is helpful because it will enable you to paint with more confidence, books and magazines are never a substitute for direct observation. When you are working outdoors, whether in a zoo or on a farm, try to keep your sketches simple, concentrating on the main lines and shapes without worrying about details such as texture and coloring. If the animal moves while you are sketching, leave it and start another one—several small drawings on the same page can provide a surprising amount of information.

You may find it difficult at first, but making quick sketches is an acquired skill and you really will get better with practice, partly because you will be unconsciously teaching yourself to really look at your subject in an analytical and selective way. You will also enjoy the freedom that sketching allows and the feeling of boldness that it generates.

• SUBJECT •

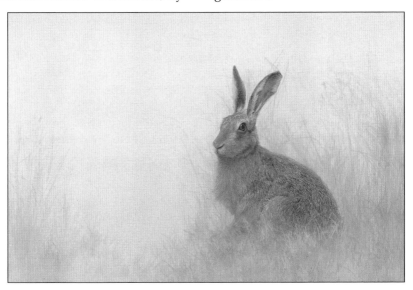

BROWN HARE by John Wilder

Glossary

ALLA PRIMA A direct method of painting in which an image is developed in wet pigment without reliance on preliminary drawing or underpainting.

BINDER A medium that can be mixed with powder pigment to maintain the color in a form suitable for painting or drawing.

BLOCKING IN The technique of roughly laying out the forms and overall composition of a painting or drawing in terms of mass and tone or color.

BODY COLOR PAINT Paint, such as gouache, that has opacity and therefore covering power. In watercolor this can be achieved by adding white to eliminate transparency.

BROKEN COLOR An effect achieved by using colors in a pure state, without blending or mixing them, and dragging paint of a stiff quality across the support so that previous layers can be seen through the new application.

CHARCOAL A drawing material made by reducing wood, through burning, to charred, black sticks.

COMPLEMENTARY COLORS There are three basic pairs of complementary colors, each consisting of one primary and one secondary color. These are opposite colors in that the primary is not used in mixing the secondary; thus blue and orange (red mixed with yellow) are complementary colors.

COMPOSITION The arrangement of various elements in a painting or drawing; for example, mass, color, tone, contour, etc.

DRY BRUSH A means of applying watercolor with a soft, feathery effect by working lightly over the surface with a brush merely dampened with color.

FIGURATIVE This term is used in referring to paintings and drawings in which there is a representational approach to a particular subject, as distinct from abstract air.

FORESHORTENING The effect of perspective in a single object or figure in which a form appears considerably altered from its normal proportions as it recedes from the artist's viewpoint.

FUGITIVE COLOR A paint or dye that is short-lived in its original intensity is known as fugitive.

GOUACHE A water-based paint made opaque by mixing white with the pigments.

GRAIN The texture of a support for painting or drawing.

GRAPHITE A form of carbon that is compressed with fine clay to form the substance commonly known as lead in pencils.

GROUND The surface preparation of a support on which a painting or drawing is executed.

GUM ARABIC A water-soluble gum made from the sap of acacia trees. It is used as the binder for watercolor, gouache, and soft pastels.

HALF-TONES A range of tones or colors that an artist can identify between extremes of light and dark.

HATCHING A technique of creating areas of tone with fine, parallel strokes following one direction.

HUE This term is used for a pure color found on a scale ranging through the spectrum: red, orange, yellow, green, blue, indigo, and violet.

LOCAL COLOR The inherent color of an object or surface, which is its intrinsic hue unmodified by light, atmospheric conditions, or colors surrounding it.

MASKING A technique of retaining the color of the ground in parts of a painting by protecting it with tape or masking fluid while colors are applied over and around the masked areas.

MEDIUM This term is used in two distinct contexts in art. It may refer to the actual material with which

a painting or drawing is executed; for example, gouache, watercolor, or pencil. It also refers to liquids used to extend or alter the viscosity of paint, such as gum or oil.

MODELING The employment of tone or color to achieve an impression of three-dimensional form by depicting areas of light and shade on an object or figure.

NOT A finish in high-quality watercolor papers that falls between the smooth surface of hot-pressed and the heavy texture of rough paper.

OPACITY The quality of paint that covers or obscures a support or previous layers of applied color.

PALETTE The tray or dish on which an artist lays out paint for thinning and mixing. It may be made of wood, metal, china, plastic, or paper.

PERSPECTIVE Systems of representation in drawing and painting that create an impression of depth, solidity, and spatial recession on a flat surface.

PIGMENT A substance that provides color and may be mixed with a binder to produce paint or a drawing material. Pigments are generally described as organic (earth colors) or inorganic (mineral and chemical pigments).

PRIMARY COLORS In painting the primary colors are red, blue, and yellow. They cannot be formed by mixtures of any other colors, although in theory can be used in varying proportions to create all other hues.

RESIST A method of combining drawing and watercolor painting. A wash of water-based paint laid over marks drawn with wax crayon or oil pastel cannot settle in the drawing and the marks remain visible in their original color while areas of bare paper accept the wash.

SECONDARY COLORS The three colors formed by mixing pairs of primary colors: orange (red and yellow), green (yellow and blue), and purple (red and blue).

STIPPLING The technique of applying color or tone as a mass of small dots, made with the point of a drawing instrument or fine brush.

SUPPORT The term applied to the material that provides the surface on which a painting or drawing is executed; for example, canvas, board, or paper.

TONE The measure of light and dark as on a scale of gradations between black and white.

TRANSPARENCY A quality of paint that means that it stains or modifies the color of the surface on which it is laid, rather than obliterating it. Watercolor is a transparent medium and color mixtures gain intensity through successive layers of thinly washed paint.

UNDERPAINTING A technique of painting in which the basic forms and tonal values of the composition are laid in roughly before details and local color are elaborated.

VALUE The character of a color as assessed on a tonal scale from dark to light.

WASH An application of paint or ink considerably diluted with water to make the color spread quickly and thinly. Transparency is the vital quality of watercolor and ink washes whereas gouache washes are semitransparent.

WATERCOLOR Paint consisting of pigment bound in gum arabic, requiring only water as the medium or diluent. Transparency is the characteristic of watercolor as compared with other types of paint and the traditional technique is to lay in light tones first and build gradually to dark areas.

WET-ON-WET The application of fresh paint to a surface that is still wet, which allows a subtle blending and fusion of colors. Watercolor artists often prefer to lay washes wet-on-dry so that a series of overlapping shapes creates the impression of a structured form.

Index

Page numbers in italics refer to illustrations and captions.

Picture Credits
&
Acknowledgments

The material in this book previously appeared in:

Choosing and Mixing Colors for Painting, Jeremy Galton

An Introduction to Painting with Watercolor, Sarah Buckley

Masterstrokes Watercolor, Hazel Harrison

Painting in Watercolor, Kate Gwynn

Practical Watercolor Techniques, Sarah Buckley

Techniques Source Book: Watercolor Painting, Mark Topham

Two in One Watercolor, Joe Francis Dowden

Watercolor Planning and Painting, Alan Oliver